A–Z
OF
THE ISLE OF WIGHT
Places - People - History

Wendy Turner

AMBERLEY

To my dearest family and friends, past and present
and new friendships made on the Isle of Wight.

Lake where there is no water
Needles you cannot thread
Ryde where you walk
Cowes you cannot milk
Freshwater you cannot drink
Newport you cannot bottle
Newtown which is very old

First published 2023

Amberley Publishing
The Hill, Stroud, Gloucestershire, GL5 4EP
www.amberley-books.com

Copyright © Wendy Turner, 2023

The right of Wendy Turner to be identified as the Author of this work has been asserted in accordance with the Copyrights, Designs and Patents Act 1988.

ISBN 978 1 3981 0932 2 (print)
ISBN 978 1 3981 0933 9 (ebook)

All rights reserved. No part of this book may be reprinted or reproduced or utilised in any form or by any electronic, mechanical or other means, now known or hereafter invented, including photocopying and recording, or in any information storage or retrieval system, without the permission in writing from the Publishers.

British Library Cataloguing in Publication Data.
A catalogue record for this book is available from the British Library.

Typesetting by SJmagic DESIGN SERVICES, India. Printed in Great Britain.

Contents

Introduction	5
Alpacas and Llamas (West Wight)	6
Alum Bay	7
Appley Tower, Ryde	8
Appuldurcombe House, Wroxall	9
Aviation: Sandown Airport	10
Bembridge Windmill (Grade I listed) and Wildlife	12
Black Arrow – British Satellite Carrier Rocket	13
Blackgang Chine	14
Botanic Garden, Ventnor	15
Brading Old Town Hall, Rectory Mansion and the Church of St Mary the Virgin, Brading	16
Cameron, Julia Margaret	17
Carisbrooke Castle – A Prison Fit for a King	18
Carisbrooke Castle Museum	20
Coronation Meadows	21
Cowes Week	22
Darwin, Charles	23
Dinosaur Isle, Sandown	23
Donkey Sanctuary, Ventnor – A 'Forever Home'	25
Elgar, Edward	26
Ellis, Mary	26
Ever Sculpture Garden and Cottage, Brighstone	28
Fairy Garden, Old Thatch Teashop, Shanklin	29
FastCat Catamarans	30
Floating Bridge and Chain Ferry at Cowes	31
de Fortibus, Isabella – Revamps Carisbrooke Castle	31
Garlic Farm and Festival	33
Ghost Experience	34
Godshill, the Church of the Lily Cross	35
Hammerhead Crane	37
Hooke, Robert	38
Hovercraft – The Last Remaining Hovercraft Service in the World	39
Irons, Jeremy	41
Isle of Wight Festival	42
'J'	43
Jazz: Newport Jazz Club and Isle of Wight Jazz Weekend	44
Jigsaw Puzzle Festival: St James's Church, East Cowes	45
Jousting	46
Kathleen Riddick OBE	47
Keats, John	48
King!	49
Lifeboats: Royal National Lifeboat Institution	50

(St) Mildred's Church, Whippingham	51
Museum of Ryde and the Donald McGill Postcard Museum	52
National Poo Museum	54
Needles, the	55
Old Girl – The Island's Wonder-Bus!	57
Osborne House, East Cowes	58
Paddle Steamer *Medway Queen* – From Medway to Medina	60
'Pepperpot': St Catherine's Oratory – Fourteenth-century Lighthouse	61
PLUTO – Pipe-Line Under the Ocean	62
Princess Beatrice, Governor of the Isle of Wight	63
Prison – HMP Isle of Wight	64
Quarr Abbey, Ryde – Abbey of Our Lady of Quarr	65
Ramblers IoW: Donate a Gate	68
Randonnée IoW	69
Red Squirrel Trail	69
Roman Villa	71
Scarecrow Festival: 'the Gallybaggers'	72
Shanklin Chine	73
Stargazing – Isle of Wight style	74
Steam Railway	74
Swifts	76
Tennyson, Alfred Lord	77
Thatched Church of St Agnes, Freshwater	79
UNESCO Biosphere Reserve	80
Vectis	81
Ventnor and Ventnor Fringe	82
Victoria's Island Trail	83
Walk the Wight – Mountbatten IoW	84
Wallis, Barnes – The Dam-Busters and the Bouncing Bomb	85
White-tailed Eagles	86
Wildheart Animal Sanctuary	87
Wroxall: The Sunshine Loop	88
Xylophone Fence	89
Yarmouth Harbour	90
Yaverland	91
Zig Zag Road, Ventnor	92
Zion Chapel, Ryde	93
Acknowledgements	94
Bibliography	95
About the Author	96

Introduction

> 'It is impossible to imagine a prettier spot.'
> Queen Victoria, speaking of Osborne House

The picturesque Isle of Wight is a place of exciting contrasts. It is one of the top five sunniest places in the UK, yet at high tide becomes one of its smallest counties. It offers around 60 miles of stunning beaches with seafront promenades, rock pools, multi-coloured cliffs and the famous Needles – gigantic white chalk rocks striding out into the sea, crowned by a nineteenth-century lighthouse. The Isle of Wight is also known as 'Dinosaur Island' for the twenty-five or so different dinosaur species that once roamed here.

Yet the Island has a darker side: a king once took refuge here from his enemies and numerous notorious criminals have been imprisoned at HMP Isle of Wight.

The island is a UNESCO Biosphere Reserve, one of only seven in the UK. It is also a place of elegant castles and monuments, with much Roman and ancient history. You can follow Queen Victoria's Island trail to some places of outstanding beauty, and walk through the centuries with Charles Darwin, Alfred Lord Tennyson, Barnes Wallis, J. M. W. Turner and even Granny Norah and Lot's wife! While here, be sure to go off-track to catch sight of the island's exquisite red squirrels and white-tailed eagles.

Whether your passion is to delve into tales of ships and smugglers, walk with dinosaurs, plunge into literature, discover wildlife, nature trails and coastal paths or simply wonder at spectacular sunsets, the 'enchanted isle' will be an ongoing journey of discovery.

Alpacas and Llamas (West Wight)

You can take an alpaca for a farm walk or a llama for a trek and enjoy stunning views over the island, or perhaps a longer walk on the beautiful Tennyson Trail. Llamas have even been known to join part of Walk the Wight to help raise funds for Earl Mountbatten Hospice. On your visit, you might be lucky enough to see an alpaca birth in the birthing field. Alpacas eat as little as 4 lbs of food per day and graze gently as they have no top teeth.

West Wight Alpacas and Llamas. (By kind permission)

Alum Bay

The history of Alum Bay goes back to movement of the sea bed and bedrock over millions of years. The stunning multicoloured cliffs of today were produced by a combination of minerals that created different colours. Twenty-one shades have been identified and tourists come from all over the world to see the spectacle and perhaps take home a souvenir of the coloured sands.

In the late 1800s Alum Bay had a modest wooden pier, which was replaced less than twenty years later by a grander one with a café and gift shop. It fell into disuse after the First World War and eventually broke up in a violent storm with no trace remaining. Today you can access the bay by taking a thrilling ride in the chairlift from the Needles (see 'Needles, the', p. 55)

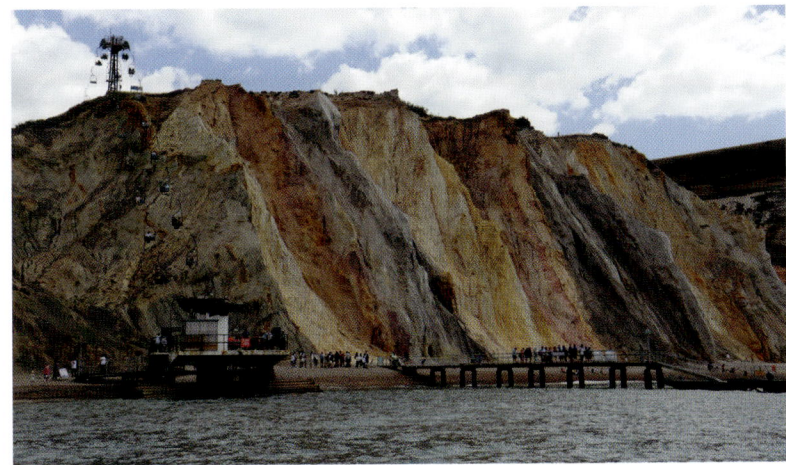

Cliffs at Alum Bay. (Photo Ray Wilkinson)

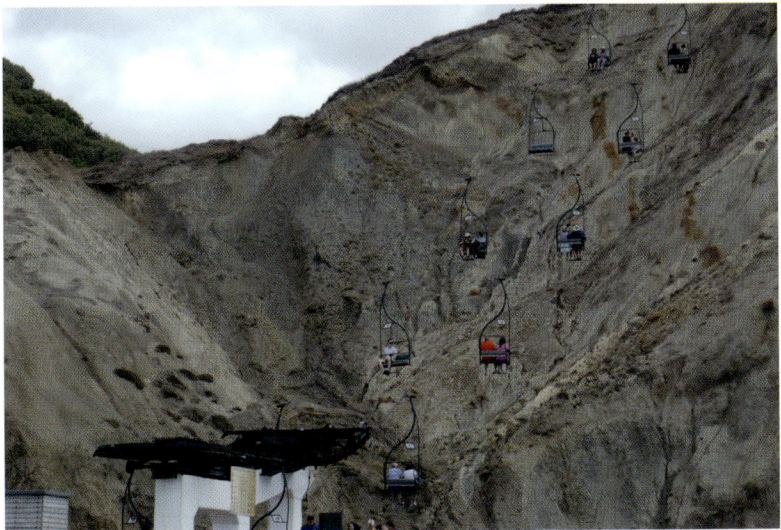

Chair lift, Alum Bay. (Photo Ray Wilkinson)

A–Z of The Isle of Wight

Appley Tower, Ryde

In 2022, the Appley Tower Players, a new theatre group of local Ryde residents, celebrated the history of Appley Tower with a new play, *Where There's a Will There's a Way*, an English translation of the Latin motto above the doorway of the tower. It was the motto of Sir William Hutt, who commissioned the 'Watch Tower' in 1875. The play, with extracts from Tennyson and Shakespeare, relives the Victorian life in Ryde of Sir William and Miss Brigstock, philanthropists who were key in the building of Victorian Ryde. Cllr Michael Lilley took on the role of Sir William, while Miss Brigstock was played by Maureen Sullivan of the Appley Tower Players.

Theatre is used as a creative way to help secure the long-term future of the tower and keep residents, schools and visitors updated on its restoration. Funding has been agreed with the Architectural Heritage Fund, which means that Appley Tower will be fully restored to its former glory and open to the public from 2024.

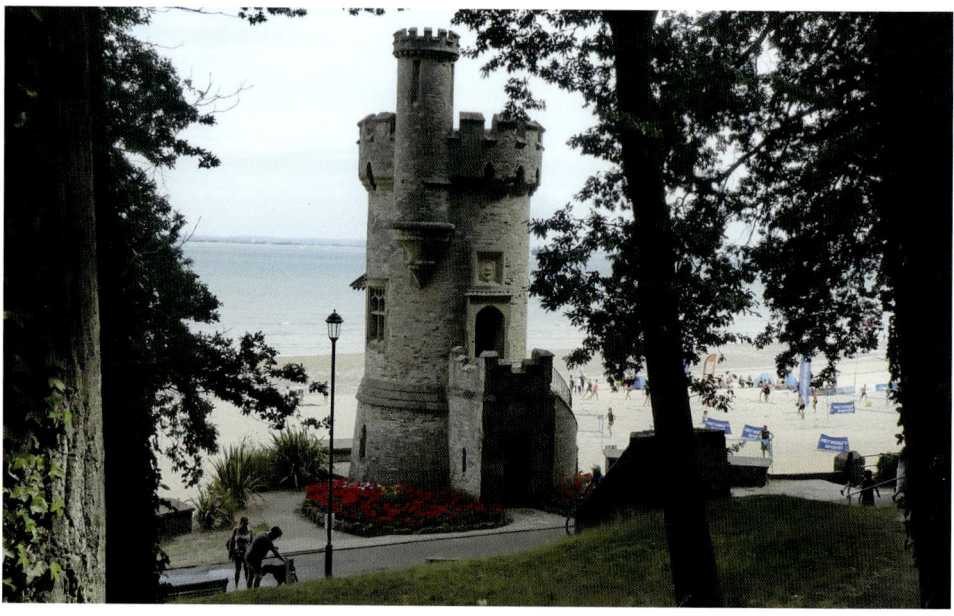

Above: Appley Tower, Ryde. (Photo Wendy Turner)

Left: Appley Tower Players. (© Christine Tout, with thanks to Cllr M. Lilley)

Appuldurcombe House, Wroxall

This impressive eighteenth-century house is now a mere shell but it was once the grandest house on the island, home to the distinguished Worsley family for around 300 years. The new house was gradually built onto an existing old Tudor house in the English baroque style. The architect was John James of Greenwich (c. 1672–1746), who also worked under Sir Christopher Wren on St Paul's Cathedral, London. Stone from the original Tudor House was reused, along with some Portland stone, which was transported by boat and then carted to Appuldurcombe.

Sir Robert Worsley began work on the house on his return from a grand tour of Europe in 1701. It was continued seventy years later by his great-nephew, Sir Richard Worsley, who made extensive alterations. The distinguished landscape designer Lancelot Capability Brown laid out the gentle, undulating grounds and the equally distinguished Thomas Chippendale planned the furniture.

Architecture included colonnades, carved scrolls and drapery, pavilions and paired chimneys resembling triumphal arches – just some of the decorative features. It had a great hall and grand staircase, a billiard room, a library and inner library containing the family's extensive art collection, bedrooms and dressing rooms, drawing and dining rooms, a kitchen, laundry, brewhouse, cellar, lodge and stables, an icehouse for storage of perishable foods, and possibly a chapel. There was also Sir Richard's Bath and a porte cochère – a porch wide enough to accommodate carriages.

Appuldurcombe House, Wroxall. (Photo Wendy Turner)

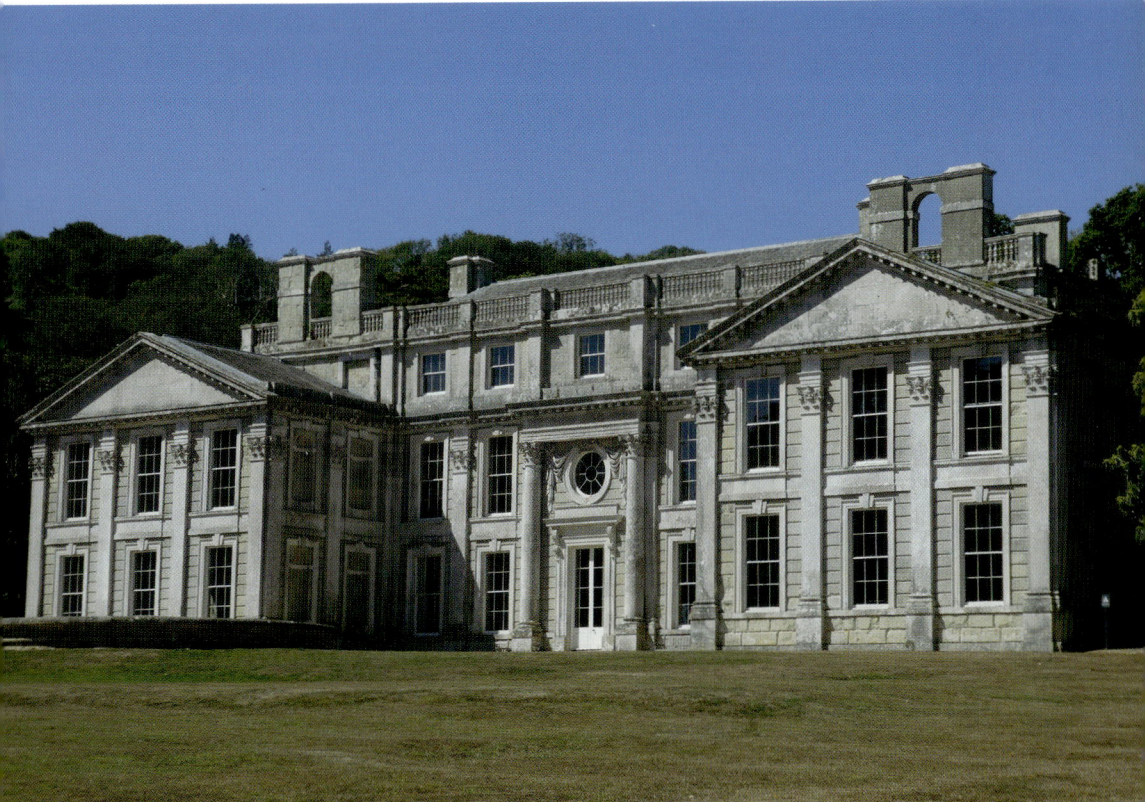

A–Z of The Isle of Wight

The estate was sold in 1855. Short-term plans for it included a hotel, school and temporary accommodation for monks, who eventually found a new home at Quarr Abbey (see 'Quarr Abbey, Ryde', p. 65). From 1909 it was uninhabited except by troops in the First and Second World Wars. By the 1950s the house had all but fallen into ruin but was rescued by English Heritage with a programme of repair and consolidation. Once again, the house stands tall and graceful, albeit empty, within its rolling grounds.

In 1703, Appuldurcombe was badly damaged by a great storm resulting in Sir Robert having to cancel the planned entertainment for Charles III of Spain who had taken shelter on the Isle of Wight.

Appuldurcombe House is Grade I listed and a Scheduled Monument.

Aviation: Sandown Airport

The airport's present location is its third home. It was previously located at Shanklin and then moved a little to the north-east before settling near Sandown. During the Second World War the airfield, like most others, was closed and their runways were blocked. Today, Sandown Airport is a popular destination for pilots from all over the UK, attracting over a hundred aircraft per day at peak times. It is also the usual departure point (or waypoint for those not landing) for private aircraft travelling to the Channel Isles and northern France, around 60 miles over water. The airport has

Sandown Airport with *Black Arrow*. (Photo Ray Wilkinson)

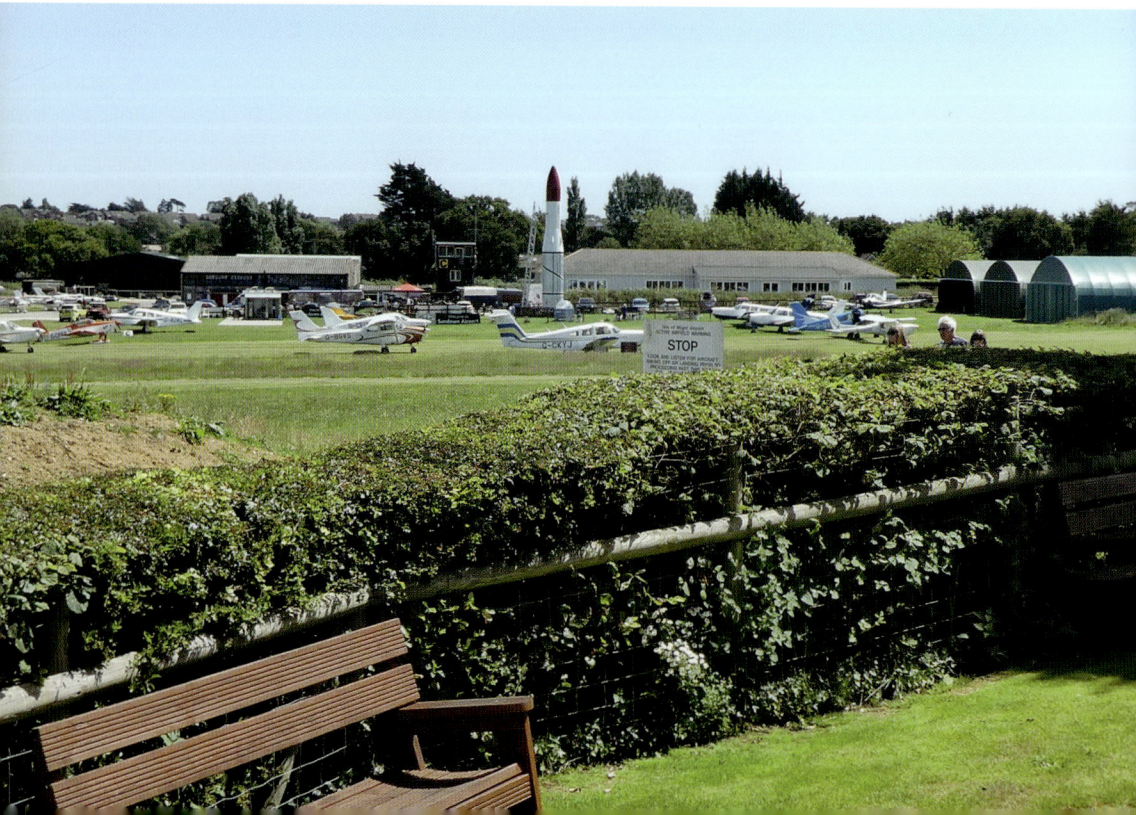

Wight Aviation Museum. (© Wight Aviation Museum, Sandown Airport)

a resident flying school, training on fixed-wing microlights and also offers helicopter pleasure flights and skydive for out-of-this-world views over the island and beyond.

Sandown Airport has an 880-metre grass runway and the only Astroturf runway in the UK. The length and surface are suitable for a range of aircraft from the very smallest to six-seater light varieties. The airport hosts many specialist events, including music and entertainment, scooter and car rallies and cycle racing. An annual highlight is Spamfield, a microlight weekend summer fly-in. The airport's bistro was originally opened by the celebrated former wartime ATA pilot Mary Ellis (see 'Ellis, Mary', p. 26).

The Wight Aviation Museum, based at Sandown Airport, celebrates the island's long history of aircraft and spacecraft. It created a full-sized replica of the *Black Arrow* rocket, which is on display at the airport (see '*Black Arrow*', p. 13).

A visit may well leave you yearning for more, as in the airport's declaration: 'Once you have tasted flight, you will forever walk the earth with your eyes turned skyward, for there you have been and there you will always long to return.'

Bembridge Windmill (Grade I listed) and Wildlife

The only surviving windmill on the island is located at Bembridge. Built in the early 1700s, it operated for around 200 years until much of the workforce left the island at the start of the First World War. It fell into disuse, but rescue and restoration came in 1961 in the form of the National Trust, with assistance from local fundraising and the Culture Recovery Fund.

The windmill was used as a shelter by the Volunteer Reserve during the First World War and as the Home Guard's HQ in the Second World War. Much of the original

Bembridge Windmill. (Photo Ray Wilkinson)

apparatus survives and a trek up the steps reveals its fascinating past. The celebrated artist J. M. W. Turner visited Bembridge in 1795 and was so taken by the picturesque windmill near the sea that he began a watercolour. You can see a copy of the unfinished work in the kiosk.

Bembridge Harbour is a Site of Special Scientific Interest (SSSI). It is also designated a Special Protection Area (SPA) and a Wetland of International Importance. A host of waterfowl feed on the shoreline, particularly during migration and in winter. You could well spot little grebe, oystercatcher, lapwing, redshank, flocks of teal and cormorant spreading their wings, to name but a few and dependent on the season. Water taxis run from the Duver pontoon to various locations around the harbour.

Black Arrow – British Satellite Carrier Rocket

The years between 1969 and 1971 saw four firings of *Black Arrow*. It was built at Cowes and tested at the Needles before its launch in Woomera, Australia. Much of the technology used came from that previously flight-tested on the *Black Knight* rocket and the *Blue Steel* missile. The name *Black Arrow* came from the practice of the Ministry of Supply to assign a colour and noun to research programmes undertaken by the military, but the programme was terminated by the government in 1971 on economic grounds.

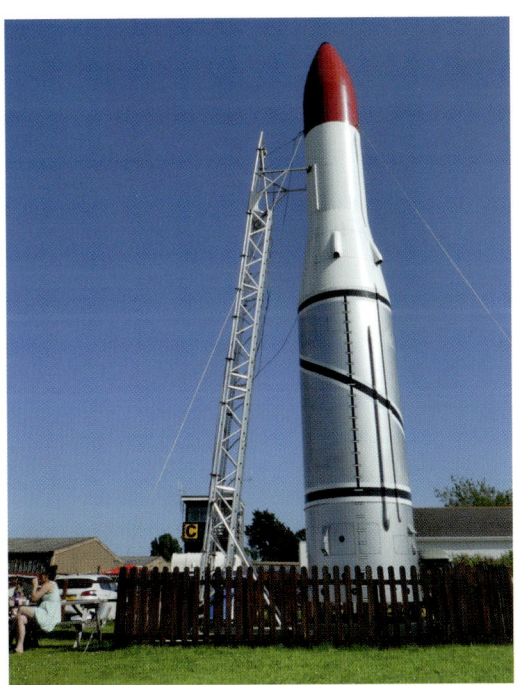

Black Arrow, Sandown Airport.
(By kind permission)

Prospero was the first British satellite to be successfully launched by a British rocket. Its name is linked to the Shakespearean name in that it refers to the many malfunctions of the *R2* rocket, likened to the misfortunes that befell Prospero, Duke of Milan, in *The Tempest*. *R3 Black Arrow* successfully launched the *Prospero* satellite. Its mission was to test technologies necessary for communication satellites. It is in a low Earth orbit and is expected to remain so until around 2070.

Black Arrow's success became something of a cult among the space community. Due to its prominent colour scheme of stripes on its first stage for determining roll angle, and with a brilliant red top for increased visibility, it became fondly known as 'the lipstick rocket'. A replica *Black Arrow* stands in the Rocket Park at Woomera and another at Sandown Airport, home of the Wight Aviation Museum that brings together and displays the island's vast aviation history.

Blackgang Chine

In 1842, a stone-throwing event secured the land that became Blackgang Chine. The stone in question was hurled by Nottinghamshire lace maker Alexander Dabell after it had been agreed that where it landed would denote the boundary of his lease. He was drawn to the area after a hotel was built there and, in a light-bulb moment, saw its potential. He cleared the rough terrain and created pretty clifftop gardens, trails and steps down the gorge to the beach, turning the landscape into a paradise for Victorian families. His vision at Blackgang saw the birth of the UK's oldest theme park, which today features pirates, fairies, cowboys, dinosaurs and a host of magical attractions.

In the same year, a huge whale was washed ashore near the Needles. An auction followed and Alexander secured its skeleton for Blackgang Chine, where it is still a major attraction. The park was put well and truly on the map when Queen Victoria arrived for a closer look at the skeleton in 1853.

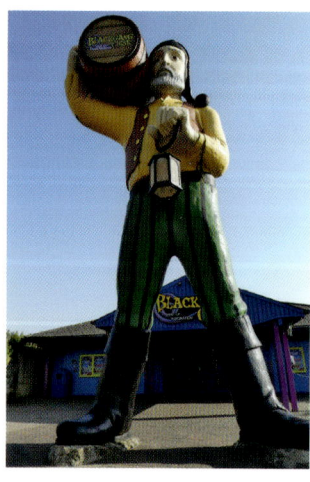

Blackgang Chine. (By kind permission)

Botanic Garden, Ventnor

You can visit the hottest garden on the island, named for its Mediterranean-like climate due to shelter from cold and strong winds from the south-facing Undercliff. Ventnor Botanic Garden promotes the 'Ventnor Method' where plants are allowed to grow naturally together in their environment, resulting in more habitats, food and shelter for small birds and mammals. It also saves on water, energy and labour.

VBG was founded in 1970 by English horticulturalist Sir Harold Hillier, who later donated it to the Isle of Wight Council. It was opened in 1972 by Lord Louis Mountbatten, Governor of the Isle of Wight, and is spread over 22 acres. VBG sits on the site of the old Royal National Hospital for Chest Diseases, whose patients also benefitted from the mild climate.

The garden sustains thousands of rare and subtropical trees and plants from all over the world. There are many delightful and varied gardens to visit, including the Medicinal and Herb Garden, Cacti and Succulents, Palm Garden, Hop Yard, Mixed Planting and Tropical House, with gardens representing different countries including South Africa, New Zealand, Australia and Japan. Look out for the wall lizards, particularly in the Mediterranean Garden, details of which can be found in the Lizard Safari Trail leaflet. Even on New Year's Day there are over a hundred plants in bloom. Seeds and plants are available to take home.

Ventnor Botanic Garden. (Photo Wendy Turner)

Brading Old Town Hall, Rectory Mansion and the Church of St Mary the Virgin, Brading

The Old Town Hall was built in the 1730s. The cell on the ground floor, once known as 'the blind house' for lack of windows, held lawbreakers in its bleak interior. The stocks and the grim whipping post also remain.

The town's precious artefacts are kept upstairs. These include a charter dated 1547 confirming the town's right to self-governance. It is signed and sealed by the monarch, the nine-year-old Edward VI, son of Henry VIII. The document also includes a rare portrait of the boy-king. The two constables' old staves and handcuffs survive, as do the town's original weights and measures, all kept in the 1819 Brading Town Chest, though some records and artefacts date from medieval times. In the 1750s the upper room was used as a school for local poor children and from 1877 it was Brading Free Library. Some cherished volumes of Shakespeare are still displayed. The Old Town Hall is now a heritage site.

The Rectory Mansion is one of the oldest timber-framed houses on the island, believed to date from the sixteenth century. It once housed the island's waxworks and even a chamber of horrors! The building is now used for commercial units.

The first baptisms to be held on the island took place in the medieval Church of St Mary the Virgin in the ninth century. The church is also credited with being the first to use movable numbers on hymn boards, possibly inspired by the eighteenth-century clergyman and writer Legh Richmond.

Above left: Rectory Mansion, Brading Old Town Hall and Church of St Mary the Virgin. (Photo Wendy Turner)

Above right: Stocks, Old Town Hall, Brading. (© Chris Offer, with thanks to Elizabeth Manning and Ruth Waller)

C

Cameron, Julia Margaret

Julia Margaret Cameron (1815–79), the distinguished Victorian photographer, lived and worked at Dimbola, Freshwater Bay. Her formidable drive and ambition to succeed in the world of photography transformed the art of the day into powerful close-up portraits of young and old along with both the local and world famous, including the Victorian poet laureate Alfred Lord Tennyson, poet H. W. Longfellow and Charles Darwin, many presently displayed in galleries worldwide. Dimbola is now a museum and gallery exhibiting work and photographic exhibitions from around the world. It is preserved by the Julia Margaret Cameron Trust.

A life-sized statue of rock legend Jimi Hendrix is a pleasing visitor attraction at the entrance to Dimbola. The portrait of Alfred Lord Tennyson (see 'Tennyson, Alfred Lord', p. 77) is the work of Julia Margaret Cameron.

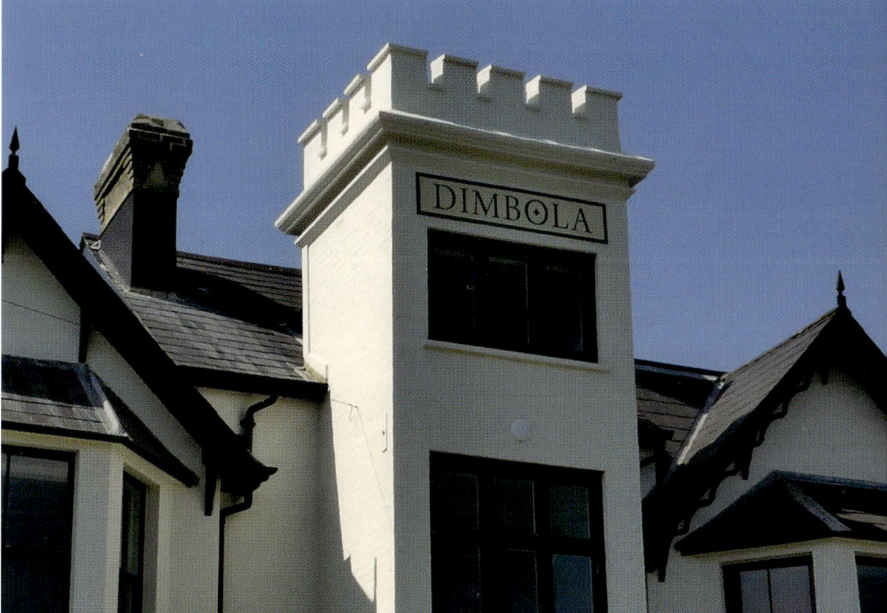

Home and studio of Julia Margaret Cameron. (By kind permission)

A–Z of The Isle of Wight

Carisbrooke Castle – A Prison Fit for a King

Carisbrooke Castle stands in a high defensive position overlooking much of the island and the Solent to the mainland. Entry is through its massive gatehouse with its huge drum towers, named for their cylindrical shape, with the gun ports and cross-shaped archers' slits of the warfare of yesterday.

The site was in use as a cemetery from the sixth century. After the Norman Conquest, a huge motte-and-bailey castle was built under Richard de Redvers, appointed Lord of the Isle of Wight by Henry I (1100–35). It was later fortified further to counter the threat of French and Spanish invasion.

At the time of the conflict between Stephen and Matilda, Baldwin, son of Richard de Redvers, supported Henry's daughter Matilda's claim to the throne. Stephen laid siege to the castle and Baldwin was forced to yield when its well ran dry. Baldwin recovered his lands just before Stephen's death and the de Redvers family continued in power on the island for the next 200 years or so. Countess Isabella de Fortibus, the last of the de Redvers family, transformed the castle into a residence fit for a king, with a great hall and a private chapel among many other fine works both inside and outside of the castle (see Isabella de Fortibus p. 31).

The castle's most famous resident was Charles I, who fled from the mainland to the island during the Civil War (1642–51), pursued by Oliver Cromwell and the

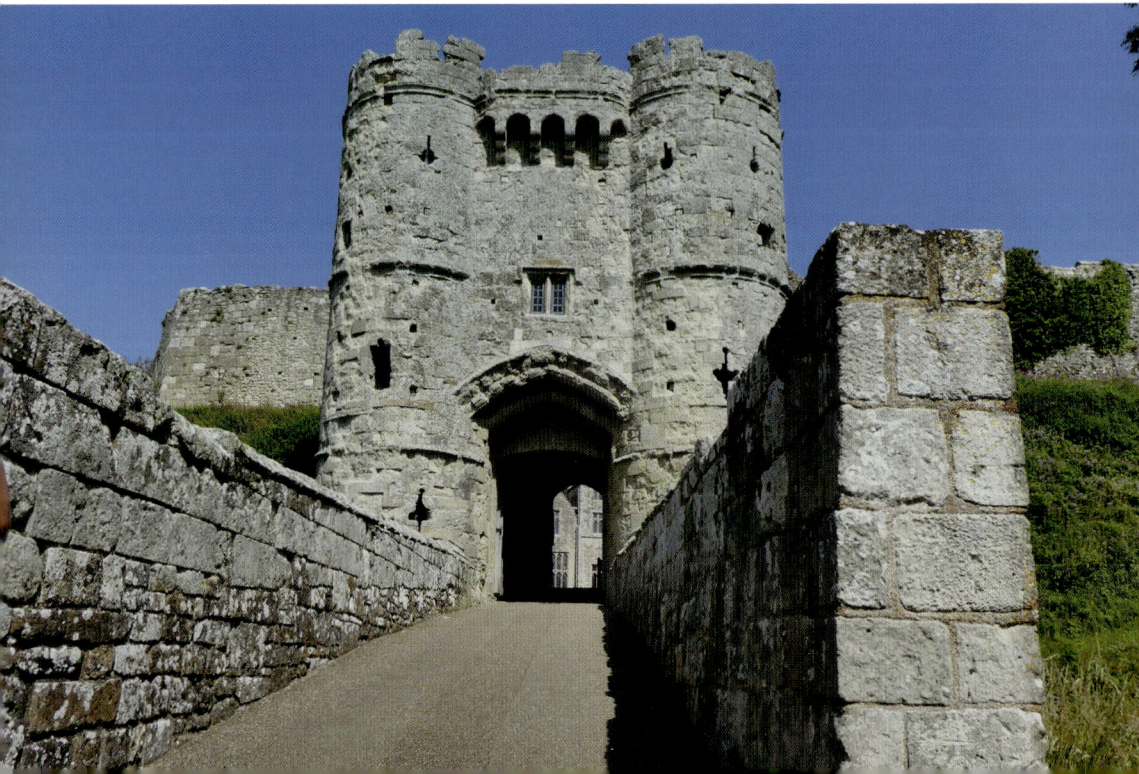

Carisbrooke Castle. (Photo Wendy Turner)

Above: Carisbrooke Castle. (Photo Ray Wilkinson)

Right: Knights' tournament, Carisbrooke Castle. (Photo Ray Wilkinson)

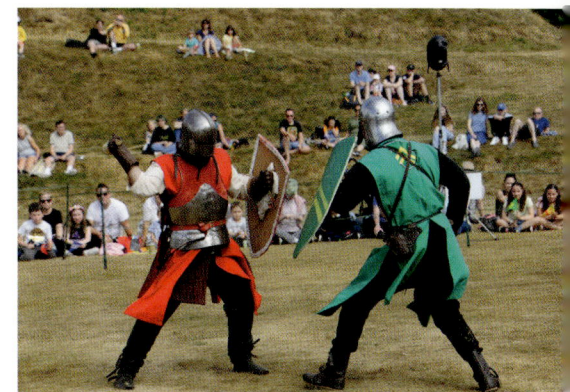

Parliamentarians. The castle became his prison from 1647–48, under the close watch of the Parliamentarian governor, Colonel Robert Hammond, but the king was allowed freedom to hunt and hawk, play bowls on his bowling green and enjoy sumptuous banquets. Daring escapes were planned with his friend Henry Firebrace. One plan aimed to lower the king over the castle wall, where a horse would be ready to take him to a waiting boat, perhaps to join the queen in France. The plan backfired when Charles was unable to wriggle through his bedchamber window – perhaps the banquets were all too sumptuous! A second escape attempt ended in betrayal and Charles was removed to Newport. Talks with Parliament were held at the Old Grammar School, Newport, which bears the date 1614 and is one of the island's oldest buildings. Negotiations failed and ultimately the king was returned to Whitehall and beheaded on 30 January 1649.

A–Z of The Isle of Wight

The castle became the residence of the island's governors, including Princess Beatrice, youngest child of Queen Victoria (see 'Princess Beatrice, Governor of the Isle of Wight', p. 63). Its strategic importance faded with the coming of Henry VIII's coastal defences and it was used as a store depot and a military hospital. The castle remains the centre for ceremonial events and pageantry and its chapel is the island's war memorial.

You can see a re-enactment of how donkeys worked a sixteenth-century treadmill to bring up water from the well. Today donkeys are allowed to demonstrate for only a few minutes each day and are well groomed and cared for. All their names begin with the letter 'J' in memory of Charles I, who signed his secret letters 'J' (see 'J', p. 43).

Carisbrooke Castle Museum

Carisbrooke Castle Museum was founded in 1898 and opened by Princess Beatrice, youngest child of Queen Victoria, in memory of her husband Prince Henry of Battenberg, who died of malaria after fighting in the Anglo-Ashanti War. As the museum's collection expanded, it was relocated from the gatehouse to the former governor's residence in the castle.

In 1650, two of Charles I's children, fourteen-year-old Princess Elizabeth and her younger brother, Prince Henry, were held at Carisbrooke Castle by Parliament. The children were caught in a downpour on their father's bowling green and the little princess, a frail child who was still grieving for her father, became ill and died of pneumonia. Ten-year-old Henry was held for three years before being allowed to join his family in exile in France. Relics of Princess Elizabeth can be seen in Carisbrooke Castle Museum: a ring containing fragments of her dress, a model of the memorial

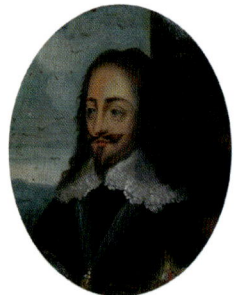

Above left: Miniature portrait of Charles I, *c*. 1640–60. (© Carisbrooke Castle Museum Trust)

Above middle: Nightcap of Charles I said to have been worn by the king on the night before his execution. (© Carisbrooke Castle Museum Trust)

Above right: Garnet ring of Charles I given to young Tobias Howe, who planned to defend the king with his wooden sword. (© Carisbrooke Castle Museum Trust)

in St Thomas' Church, Newport, where she is buried, and a Victorian painting of her death.

Some of Charles' personal items, such as his nightcap, believed to have been worn the night before his execution and given to the museum by Queen Victoria, are displayed in the museum. You can also see part of his walking stick, his Bible and prayer book and the coded letters plotting his escape that he wrote during his imprisonment. Some of the text has yet to be deciphered.

The museum is preserved under a charitable trust set up by Princess Beatrice to enable it to continue displaying the island's precious artefacts. Carisbrooke Castle Museum is the only public museum in the UK founded by a member of the royal family.

Coronation Meadows

The Coronation Meadows Project is led by Plantlife in partnership with The Wildlife Trusts and the Rare Breeds Survival Trust. Its patron was the former Prince Charles, now Charles III. The aim was to celebrate the 60th anniversary of the coronation of Elizabeth II by ensuring that a wildflower meadow was established in every county across the UK and help restore the 97 per cent of meadows in the UK that have been lost over the last seventy-five years.

Meadow. (Photo Ray Wilkinson)

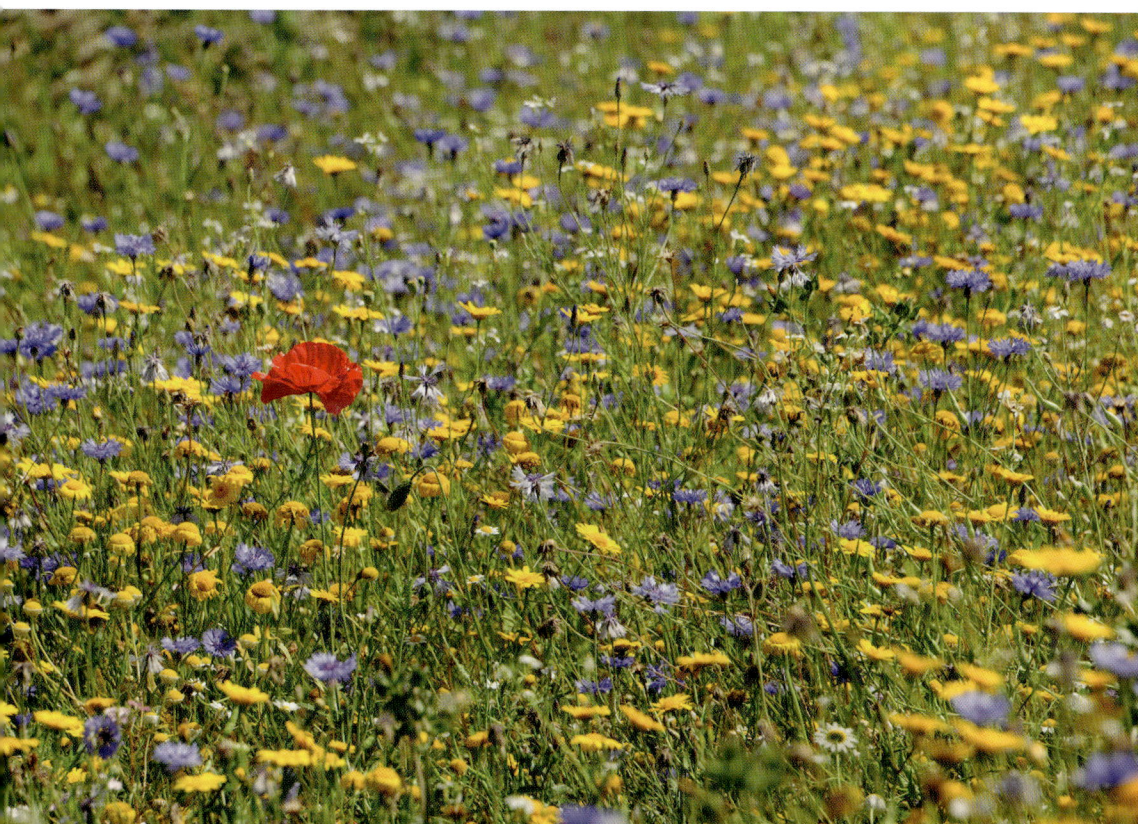

Plantlife's 2012 publication, *Our Vanishing Flora*, listed wildflowers deemed lost since the coronation, as reported by Britain's counties. The project identifies a flagship 'Coronation Meadow' in each county and aims to establish new wildflower meadows to help protect Britain's flowers, mosses, ferns, grasses and lichens. Part of the scheme's success stems from taking seeds from an established donor Coronation Meadow for a new recipient meadow in the same county, thereby creating new wildlife habitats while maintaining its special local charm. Over ninety new meadows across 1,000 acres have been established through the project, which works with conservation organisations, partners, volunteer groups and landowners to secure our wildlife heritage for future generations.

Coronation Meadows blaze with favourites such as ox-eye daisies, bird's-foot trefoil and cowslips, but rarer plants like the green-winged orchid and common-spotted orchid may also be seen. There's also the brilliant yellow dyer's greenweed (traditionally a light, fast lemon dye and an important food source for rare moths and insects) and devil's-bit scabious, irresistible to a wide variety of butterflies and bees.

Swiss Cottage at Osborne House hosts the island's Coronation Meadow.

Cowes Week

The annual summer regatta at Cowes began in 1826 and is a major highlight on the sporting calendar, not only in the UK but worldwide. Up to 1,000 boats with around 8,000 crew members tackle around forty daily sailing races. They arrive from fifteen or so countries, most from the UK but also from the US, the Netherlands, Australia, Hong Kong and many more. Up to 100,000 spectators arrive to enjoy the spectacle on the sea and the live music, food and drink onshore, giving the event a truly international and festive atmosphere.

While at the regatta, why not try your hand at some of the water-based sports available for all ages, and stay on for the traditional spectacular firework party on the last Friday.

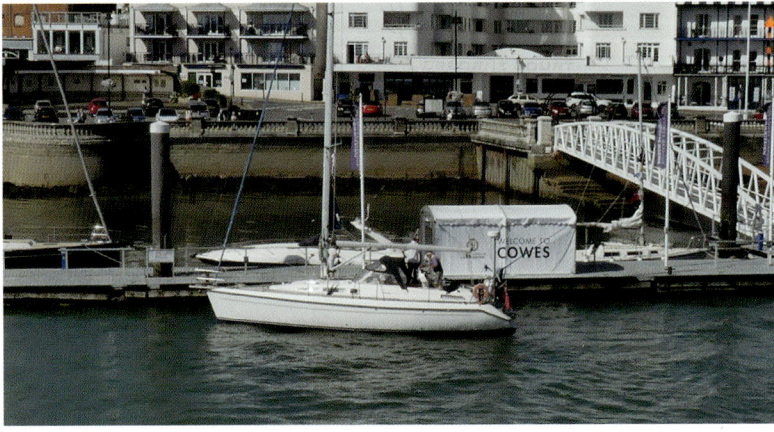

Cowes Harbour. (Photo Ray Wilkinson)

D

Darwin, Charles

Charles Darwin (1809–82) was born in Shrewsbury, Shropshire. He was the fifth of six children of Dr Robert Waring Darwin and Susannah Wedgwood, daughter of the renowned ceramicist and anti-slave campaigner Josiah Wedgwood.

Darwin studied Divinity at Cambridge and seemed destined for the church, but in the early 1830s his tutor suggested he join HMS *Beagle* on an expedition around the world. Darwin was keen to pursue his great love of biology and geology and spent the next five years travelling over four continents, arriving at such far-flung places as the Galapagos Islands and New Zealand. On the voyages he amassed a huge range of plants, insects and geological specimens. He arrived back home in 1836 pondering his idea of the connectivity of every living thing over millions of years. His theory of evolution by natural selection was based on his vision of ever-increasing populations competing for resources, resulting in the survival of the fittest.

In 1839, Darwin married his first cousin, Emma Wedgwood. They had ten children, three of whom died in childhood, including his last child, a son, of scarlet fever at the age of eighteen months. Darwin mourned the loss of his children and suffered long periods of ill health. In a bid to escape the ravages of sickness in larger towns and cities, he moved his family to the little village of Downe in Kent. In the summer of 1868, he rented a cottage at Freshwater on the Isle of Wight from the celebrated portrait photographer Julia Cameron (see 'Cameron, Julia Margaret', p. 17).

Darwin's groundbreaking work *On the Origin of Species by Means of Natural Selection* was published in 1859. He died in Downe and was buried in Westminster Abbey.

Dinosaur Isle, Sandown

Do you know your *Sauropodomorpha* (sauropod-like) from your *Theropoda* (beast foot)? If not, you may well find the answer on the Isle of Wight, particularly around Compton Bay, near Freshwater, an area rich in dinosaur bones, teeth and footprints.

The Isle of Wight, also known as 'Dinosaur Island', boasts the most abundant accumulation of dinosaur remains in Europe. The two main groups are the

A–Z of The Isle of Wight

Ornithischia (bird-hipped) and *Saurischia* (lizard-hipped). At Compton Bay you can see what are believed to be huge footprint casts of *iguanodon* near the cliffs at Hanover Point, dating from 125–135 million years ago.

The cliffs at Compton Bay have been eaten away over the years by the pounding of the sea and high waves, which can cause dinosaur bones, trapped for millennia, to tumble out. You can best hunt for them at low tide on the beach. To date, more than twenty different dinosaur species have been identified on the island, some found nowhere else in the world.

Dinosaur Isle at Culver Parade, Sandown, opened in 2001. The attractive interactive museum was created in the shape of a giant pterodactyl (winged lizard) and replaced the old Museum of Isle of Wight Geology. It is thought to be the first commissioned dinosaur museum in Europe.

Left: Dinosaur footprint cast, Compton Bay. (Photo Ray Wilkinson)

Below: Dinosaur Isle, Sandown. (Photo Wendy Turner)

D

Donkey Sanctuary, Ventnor – A 'Forever Home'

The Isle of Wight Donkey Sanctuary opened in 1987. To date, over 100 Jacks and Jennies of all shapes, sizes and colours have enjoyed their new 'forever home' in 55 acres of the island's beautiful Wroxall Valley. They are cared for by a small number of part-time staff and over fifty volunteers who learn how to groom and lead donkeys and help with exercise and feeding.

The sanctuary's focus is on the rescue and welfare of donkeys who have been abandoned or in need of help. You can follow an information trail around the site, learn their stories and get up close and personal with them as donkeys love fuss and attention! The sanctuary encourages visitors to take part in welfare work by joining donkey walking or grooming sessions. Groups are especially welcome and people from residential centres, community groups or schools visit frequently. Donkeys are often out and about at village events or taking part in therapy visits in day centres and nursing homes. When at home, they spend most of the day grazing. They need forage of oat or barley straw and grass plus the daily bale of hay that the sanctuary provides, together with salt blocks for essential minerals. Visitors are likewise welcome to graze in the sanctuary's *Grazers Café* in the barn!

The sanctuary is also an education centre for learning and training for children, students and apprentices. The 'classroom in a stable' offers practical work sessions along with the study of the history and the role of donkeys on the island. It is dependent on donations, fundraising events and their *Browse and Brays* gift shop to continue providing care. For a modest annual fee you can choose a donkey from the website to adopt, and there are plans to venture into birthday parties along with caring and leading donkey days. A happy donkey likes nothing better than a good roll about and they have been known to serenade visitors at musical events! The charity says, 'It is not just what we do for our donkeys, but what our donkeys do for people.'

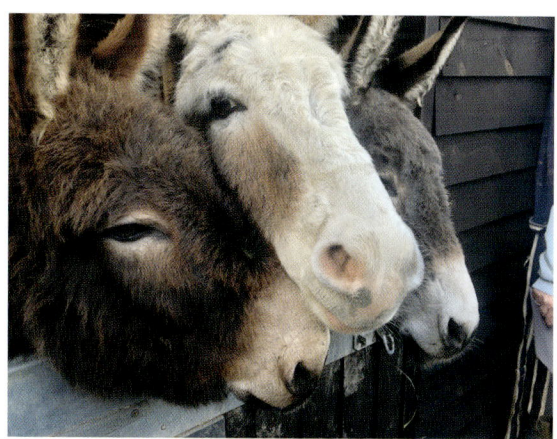

Isle of Wight Donkey Sanctuary, Ventnor. (© Donkey Sanctuary Ventnor)

E

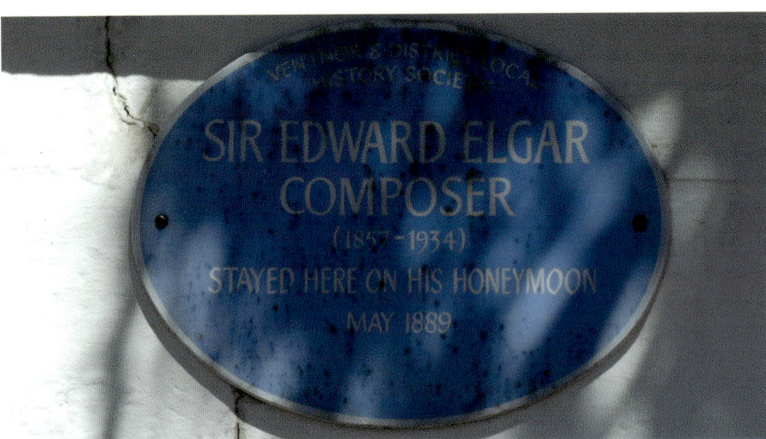

Elgar plaque, Ventnor. (Photo Wendy Turner)

Elgar, Edward

Sir Edward Elgar (1857–1934), composer of *Land of Hope and Glory*, came to the Isle of Wight after marrying Alice Roberts in 1889. The couple spent their honeymoon on the first floor of No. 3 Alexandra Gardens, Ventnor. The landlady announced their arrival in the *Isle of Wight Advertiser*.

Ellis, Mary

Born in 1917, Mary's love of flying was sparked at the age of eleven when her father took her to a flying circus offering rides in a de Havilland 60 Moth biplane. So inspired was Mary that by the age of seventeen she had gained her civilian pilot's licence.

During the Second World War, Mary joined the Air Transport Auxiliary (ATA) as a ferry pilot, delivering new fighter and bomber aircraft from factories to active airfields around the UK and flying back damaged aircraft. Her formidable list included Spitfires, Hurricanes, Harvards and huge Wellington and Lancaster bombers. Throughout her career Mary flew over 1,000 aircraft of seventy-six different kinds.

ATA personnel were equipped with only a compass, maps and their Ferry Pilots Notes, a pocket-sized series of cards with information on RAF aircraft and speeds, power settings and landings. They were dangerous times and Mary had to cope with many emergencies, including an engine failure over the New Forest. Happily, she landed safely in a clearing. There was also the possibility of attack by the enemy, near misses in bad weather and the hazards of landing in foggy and windy conditions. Fifteen of the ATA's 168 female pilots lost their lives in service. At the time female pilots struggled to be accepted, and Mary recalled that a ground crew once doubted she was the pilot of a Wellington bomber and carried out a quick cockpit search to make sure!

Mary moved to the Isle of Wight in 1950. She was hired as personal pilot by an affluent farmer to fly him from his farms to large agricultural events around the UK in his Percival Proctor aircraft. He later purchased an airfield, which became Sandown Airport. Mary was appointed his Manager and Director of Operations, a post she held for over twenty years. She turned her hand to everyday necessities, from operating the control tower to keeping the runway free of sheep.

The Isle of Wight became a very special place for Mary. It is where she met her future husband, fellow pilot Don Ellis, whom she married in 1961. Their house was beside the runway at Sandown where she continued to live after Don's death in 2009. In her private life Mary was an elegant lady who appreciated good manners and pretty china. She loved adventure and was often victorious in local sports car rallies.

In 2016, her autobiography was published: *A Spitfire Girl: One of the World's Greatest Female ATA Ferry Pilots Tells Her Story*. Mary and fellow ATA pilot Joy Lofthouse were guests of honour at the 2016 annual Festival of Remembrance, and the achievements of Mary Ellis and her colleague Molly Rose were celebrated with a plaque, unveiled at RAF Brize Norton.

A grand party was held to celebrate Mary's 100th birthday with guests including the then prime minister, Theresa May. Among her many gifts was a birthday cake complete with a model Spitfire and a portrait of her in uniform. She was honoured

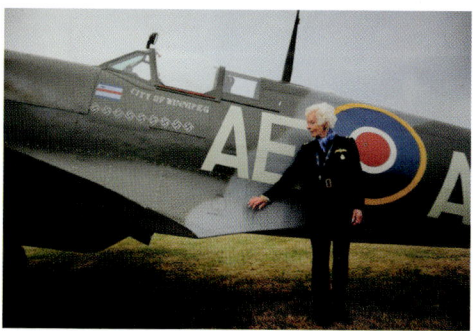
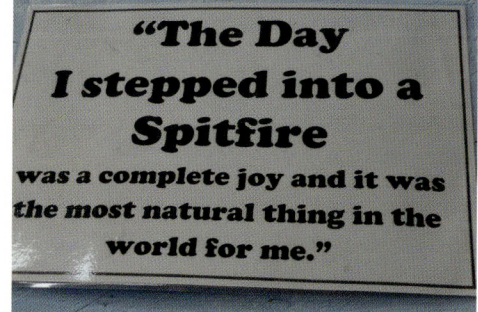

Above left: Mary Ellis. (© Wight Aviation Museum)

Above right: Mary Ellis quote. (© Wight Aviation Museum)

with the Freedom of the Isle of Wight and enjoyed a trip in her favourite aircraft, the Spitfire, making her the oldest person to do so.

Mary died in 2018 at the age of 101. The Wight Aviation Museum, based at Sandown Airport, celebrates the island's unique aviation history with a permanent exhibition of Mary's life.

Ever Sculpture Garden and Cottage, Brighstone

This eighteenth-century chalk stone cottage and garden, formerly Elmlea, neatly combine art, sculpture and artefacts reflecting the history of the cottage and grounds with traditional and contemporary plants around its landscaped borders and trails. The story of those who lived, worked and gardened here over the last century is told inside the cottage, which retains some original furniture and dressers displaying artwork made from materials found locally and on site. Some quirky and interesting echoes of its past remain, such as the stairs in a cupboard and exposed wooden beamed ceiling.

Ever Garden was created by artist Ever Grainger MRSS and opened to the public in June 2021.

The picturesque cottage of Ever Garden. (© Ever Sculpture Garden and Cottage, Brighstone)

F

Fairy Garden, Old Thatch Teashop, Shanklin

This Grade II listed building was built in 1690 as fishermen's cottages. It had a variety of uses over the years but by 1940 was transformed into today's picturesque Old Thatch Teashop, complete with its enchanted fairy garden.

Old Thatch Tea Shop, Shanklin. (By kind permission)

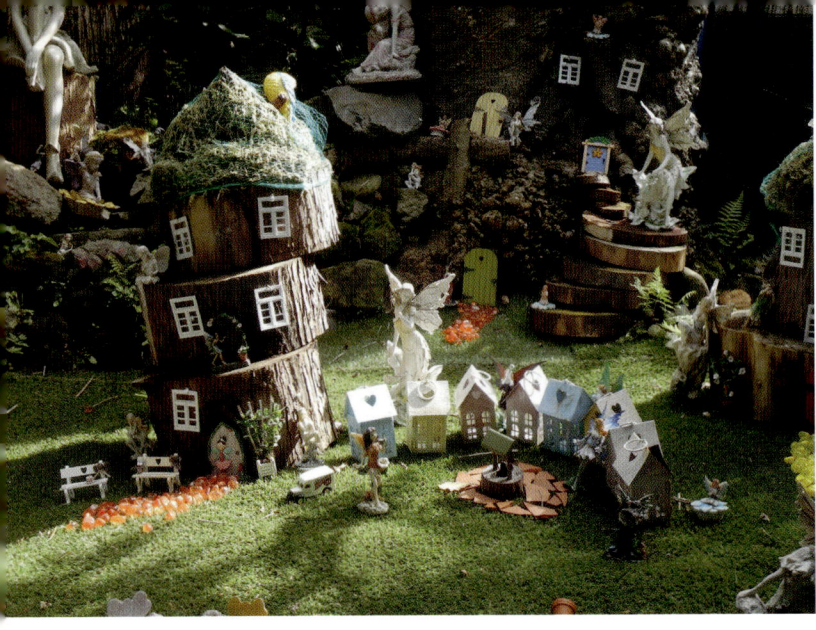

Fairy Garden, Old Thatch Tea Shop, Shanklin. (By kind permission)

The teashop is one of the oldest buildings in Shanklin and has tales of smugglers who once hid treasure in the tunnel beneath, away from the prying eyes of custom and excise officers. The apparition of a beautiful lady is also said to appear, wandering through the tea rooms, ensuring proper order is kept – perhaps it is one of the fairies!

FastCat Catamarans

Foot passengers can skim the waves from Ryde pierhead to Portsmouth Harbour in twenty-two minutes aboard a FastCat catamaran. *Wight Ryder I* and *II* offer a comfortable lounge, bicycle racks and a sun deck from which to enjoy superb views while crossing the Solent. The two vessels work together to deliver a fast, reliable service and are accessible via road and bus routes and Island Line trains, which run between Ryde pierhead and Shanklin. Ryde Pier, built in 1814, is the UK's oldest pleasure pier and one of the island's most popular fishing spots.

FastCat catamaran, Ryde. (Photo Ray Wilkinson)

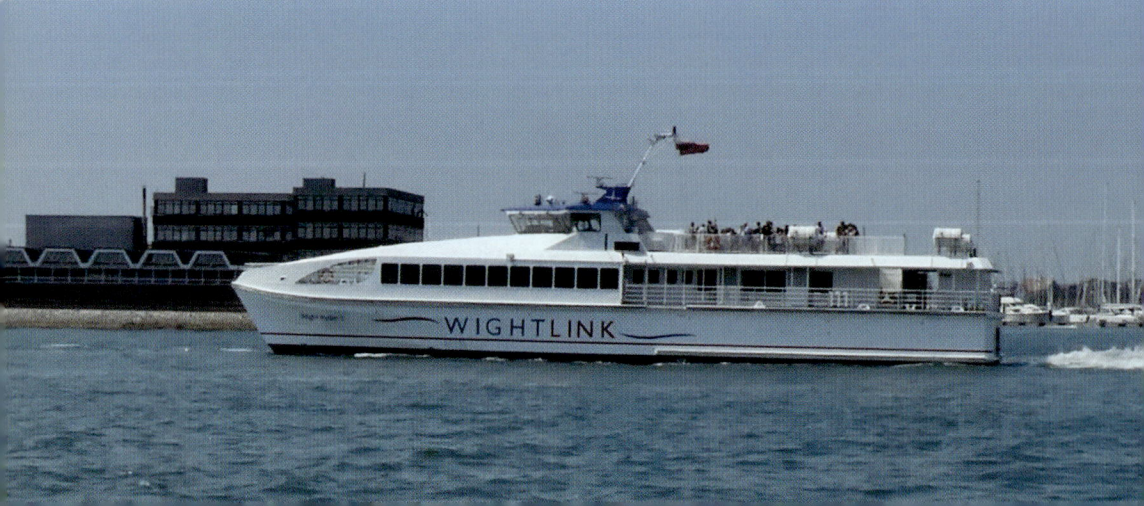

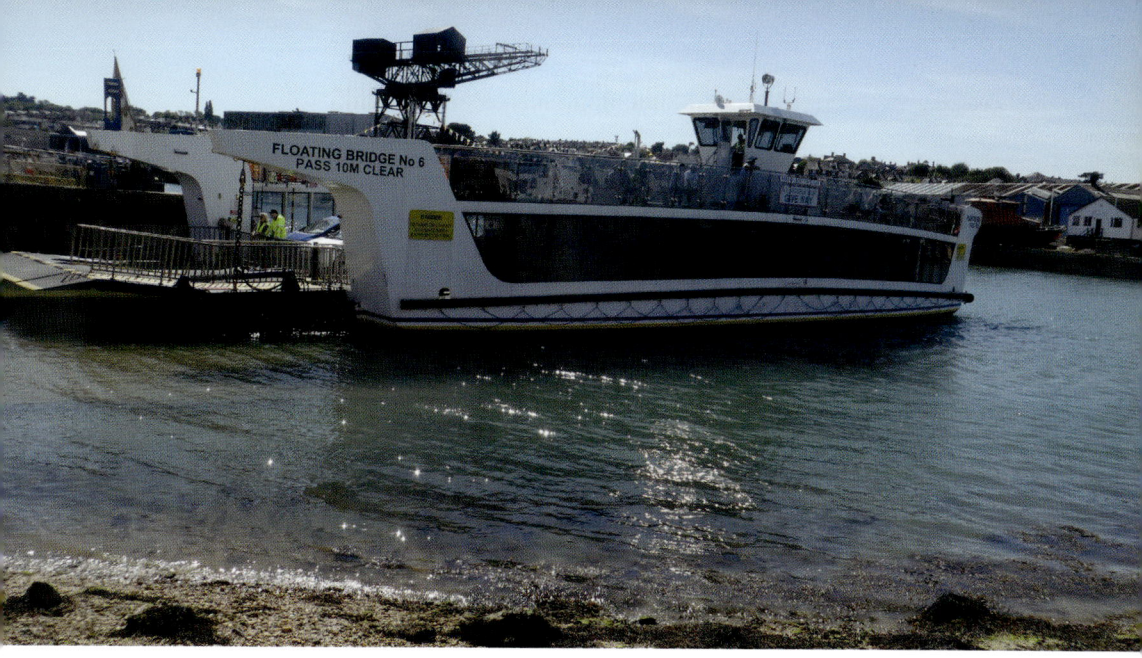

Floating Bridge and Chain Ferry, Cowes. (Photo Ray Wilkinson)

Floating Bridge and Chain Ferry at Cowes

Until 1859, the only way to cross the Medina from East Cowes to Cowes was by rowing boat. Rights to ferry people across the river were granted to the Roberton family by the island governor in 1720. Today the Floating Bridge caters for both pedestrians and vehicles, thanks to chains anchored on both sides of the river that thread their way through openings under the ferry, propelling and keeping it stable and on course. It is still referred to as a 'bridge' as it travels to both sides of the river and is one of very few mobile bridges in the UK, most having been replaced by static or swing bridges.

Before boarding take a moment to read Glyn Roberts' entertaining poem on the quayside, 'Knot Likely', which is about a mischievous person tying a reef knot in the chain. Alongside is a 'Schedule of Tolls' from 1921 where you will see a foot passenger was charged a penny to cross the river or a penny-halfpenny return. The fee for a horse-drawn carriage with driver and passenger was sixpence but, if you wanted to take your ox or bull, fivepence.

The Floating Bridge is owned and operated by Isle of Wight Council.

de Fortibus, Isabella – Revamps Carisbrooke Castle

Isabella de Fortibus (1237–93) was the last of the island's powerful de Redvers family and lived in Carisbrooke Castle, the traditional home of governors of the Isle of Wight (see 'Carisbrooke Castle', p. 18). Aged around thirteen she was married to William de

A–Z of The Isle of Wight

Fortibus, but was widowed ten years or so later after having borne four sons and two daughters. Isabella inherited her husband's vast estates on the mainland and also those on the Isle of Wight of her brother, Baldwin de Redvers, who died without an heir. It made Isabella one of the wealthiest heirs and landowners in medieval England and, as such, she fended off countless suitors, including the son of Henry III and Simon de Montfort the Younger, who unsuccessfully pursued her across England and Wales.

Isabella transformed Carisbrooke Castle from a military stronghold into a comfortable residence. Records survive giving a snapshot of her building works. She changed the main living spaces and created a great chamber for her private use, apartments for the castle's constable and a new kitchen and chapel. She is also credited with building the original gatehouse and creating a herb garden with a sundial and a fish pool. Isabella's glazed chamber windows, exceptionally expensive at the time, gave her sweeping views across the island. You can still see her window and window seat, situated at the top of the outside stone steps in the north wall of the castle.

Sadly, none of Isabella's children survived their teens, resulting in a greater challenge from the new king, Edward I. She firmly resisted his pressure to purchase her lands and the matter ended up in court where Isabella triumphed. There was nothing she relished so much as protracted litigation!

In 1293, Isabella fell ill while on her way back from Canterbury and took refuge in her manor in London. The king's councillors closed in and finally everything was signed over to him.

Isabella's story is one of a powerful woman of vision and determination. She turned her dreams into reality and fiercely protected her independence and inheritance until her dying day.

Isabella de Fortibus window, Carisbrooke Castle.
(Photo Wendy Turner)

G

Garlic Farm and Festival

'Granny Norah' certainly started something big on the island when she planted her first little garlic cloves over sixty years ago in her kitchen garden. Since then, the garlic farm has blossomed and today's tempting garlic-infused products include garlic mayonnaise, garlicky dressings, Vampire's Revenge (a hot plum chutney), roast garlic jam and horseradish mustard with garlic. You could even try some black garlic ice cream, washed down with a glass of garlic-infused beer in the popular farm shop and restaurant.

Farmer Colin Boswell spends time travelling the globe finding different garlic varieties suitable to plant at the farm, while the family run the day-to-day business. To begin with, he chose the Solent Wight, a variety from the mountains of central France that took well to the island's soil. A Mediterranean climate was created under glass to dry the big, juicy bulbs and perfect the skins. Another of the farm's speciality garlic crops is the aptly named Elephant Garlic. A little milder than usual, these enormous bulbs are delicious when roasted.

The Garlic Farm trials up to twenty-five varieties every year and supplies amateur growers across the UK and Europe as well as independent retailers across the country. Garlic planting takes place seasonally and tastes vary from the mild-tasting to the

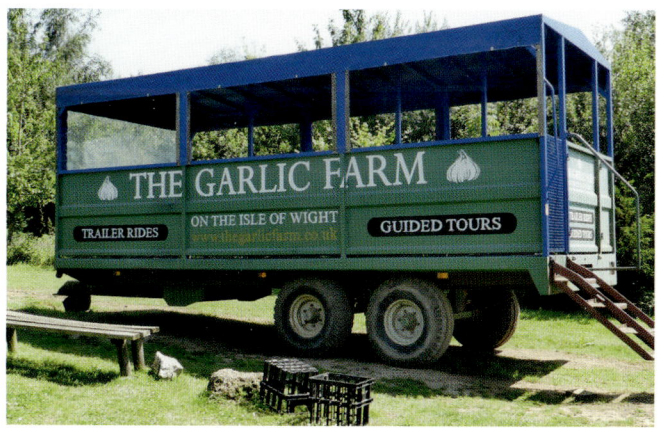

Above left and above right: Garlic Farm, Arreton Valley. (By kind permission)

A–Z of The Isle of Wight

fiery hot for dedicated garlic lovers. Vegetarians and vegans are well catered for, with suitable products of chutneys, jams and relishes with pear, peach, mango and date. Gluten-free products are also available.

One of the Isle of Wight's largest annual events, the Garlic Festival, began in 1983 and is a firm highlight on the island's calendar. The festival buzzes with food stalls, cookery demonstrations and recipes, and comes with live music and its own Garlic Queen – a pungent warning to local vampires!

In addition to its nutritional value, garlic is well documented for its anti-inflammatory properties, boosting the immune system and helping to reduce high blood pressure. Why not visit to try a Wight Little Pickle or some Wonky Wight Rustic Garlic bulbs.

The Garlic Farm was one of four Isle of Wight establishments listed in the 2020 *Good Food Guide*.

Ghost Experience

You can join a Ghost Experience at Ventnor Botanic Garden, where the gentle brush of palm fronds in the twilight certainly adds to the whole ghostly experience. The walks also start at Shanklin Old Village, Carisbrooke, Fort Victoria, Arreton, Niton

IoW Ghost Experience. (By kind permission)

and Newport. The haunting tales are well researched, and participants get to visit the actual locations of many dark deeds.

The island is credited as one of the world's most haunted places, with ample tales of phantom sailors and pirates, ladies in white, murder victims and child footprints. For the brave, there are guided tours featuring creepy tales from history played out by costumed actors, bringing to life the sights, sounds and smells of the foul play of yesterday. The Isle of Wight attracts ghost hunters from around the globe.

Godshill, the Church of the Lily Cross

The church stands high on the crown of a hill above some of the most attractive thatched cottages on the island. The present church is the fourth on the site, but churches have been here for over 950 years. Entry into the bright and beautiful church is through the huge medieval door. The ancient key is no longer in use, which is fortunate as it's 12 inches long and weighs 1½ lbs.

Today's church, with its rare double nave, dates from the early fourteenth century. Between the altars lies the magnificent Leigh Monument, tomb of Sir John Leigh and his wife Agnes, who lived at nearby Appuldurcombe House in the 1490s and whose effigies are intricately carved in Derbyshire alabaster. The monument comes complete with a jolly medieval pun in the form of two 'Bedesmen', bearded monks who sit in contemplation, holding rosary beads as they pray for Sir John's soul, carved on the soles of his feet. Sir John's feet rest on a carved pig, said to have hastened his death by tripping his horse.

The mural on the east wall of the south transept shows the wounded Christ crucified on a triple-branched flowering lily. It has been dated to *c.* 1450 and is unique in English wall paintings. The medieval artist, possibly Italian, is unknown but is deemed to have painted with great tenderness. Lilies represent purity, especially when portraying the Virgin Mary, and the lily cross becomes particularly relevant when Good Friday falls on 25 March, the Feast of the Annunciation (Lady Day). The wall paintings were limewashed at the Reformation and probably also in Puritan times, and the Lily Cross only came to light in the mid-1800s. Restoration carried out in the 1960s revealed painted curtains, the outlines of two figures and flying angels holding scrolls.

High on the wall opposite the entrance is a painting of Daniel in the Lions' Den, donated by the 1st Lord Yarborough and catalogued as 'a copy after Rubens'. The original is now in the National Gallery of Art, Washington.

The building of the church at Godshill is a mystery. Legend tells of builders starting to build a church at the foot of the hill. On three consecutive nights the stones are said to have found their way uphill to the present site and, after the third night, they understood that God had chosen otherwise. The new church was duly built uphill,

A–Z of The Isle of Wight

and it became known as 'the Hill God chose for His Church'. It is also known as the Church of the Lily Cross and appears in Simon Jenkins' *England's Thousand Best Churches*.

Picturesque Godshill church and village is one of the island's most-visited places by walkers, photographers and artists from all over the world.

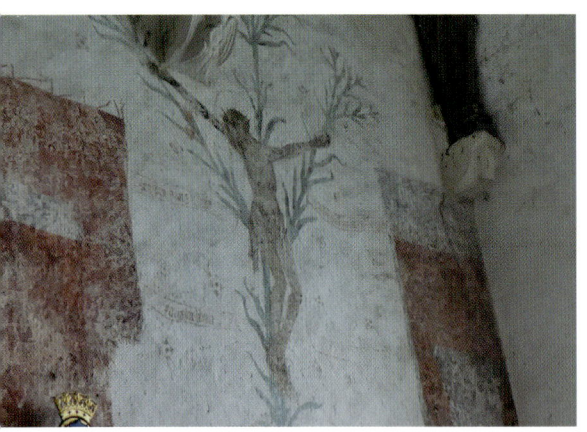 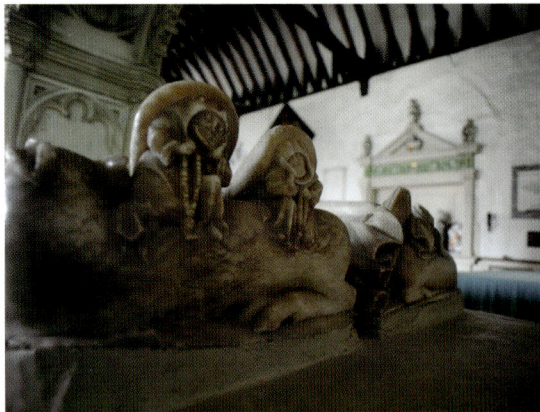

Above left: Lily Cross, Godshill Church. (By kind permission)

Above right: Bedesmen, Godshill Church. (By kind permission)

Below: Picturesque Old Smithy, Godshill. (Photo Ray Wilkinson)

H

Hammerhead Crane

The huge 1912 crane stands tall on the horizon overlooking Cowes, the River Medina and the Solent. It was commissioned by Cowes shipbuilder J. S. White and designed by Babcock and Wilcox. The crane, capable of lifting up to 80 tons, played a key part in the production of the fastest and most heavily armed warships ever built at Cowes, of which two survive, HMS *Cavalier* at Chatham and the Polish ORP *Błyskawica* (Lightning) in Poland.

During the Second World War, the island was frequently attacked by German bombers. One such raid took place in the early hours of 1942 when over 150 bombers targeted the island's ship-building works. Seventy people perished, but help came

Hammerhead Crane, Cowes. (Photo Wendy Turner)

in the form of ORP *Błyskawica*, which had returned to Cowes for an overhaul. The ship's crew joined in the defence of the island, topping up ammunition and creating a billowing smoke screen for protection against the bombers. They also teamed up with the emergency services in rescuing local residents.

The crane fell out of use in 2004. It was designated Grade II/Grade II* and put on the English Heritage 'At Risk' list. Since then the Cowes Hammerhead Crane Trust have raised its profile, and that of Cowes marine heritage, not only in public awareness but by encouraging careers in engineering and heritage-related craftsmanship. It aims to fully restore the crane, retelling its engineering and shipbuilding story to future generations and thus preserving a vital part of the island's history.

Hooke, Robert

Born in 1635 in an ivy-clad farmhouse in Freshwater, Robert Hooke (1635–1703), artist, inventor, designer, engineer, scientist, mathematician, astronomer and philosopher, has been credited with being 'the English Da Vinci'. His father, John Hooke, was a curate at All Saints' Church, Freshwater, which was in the patronage of St John's College, Cambridge.

John educated Robert with a view to life in the church, but John suffered poor health and Robert was left somewhat to his own devices. He found the world full of wonder and studied everything from animals and plants to rocky coastlines, cliffs and the sea, and spent his time making models and inventing mechanical toys.

John died when Robert was thirteen. Robert's inheritance of £40, plus £10 from his grandmother's estate, enabled him to leave the Isle of Wight for London. He planned to study art, a skill he had learnt from a visiting artist, but life took him to the prestigious Westminster School and later Christ Church, Oxford, where he came into contact with Robert Boyle, Christopher Wren and other members of the newly formed Royal Society. Ever inventive, he designed or improved on many scientific devices that continued to be used over the centuries.

Robert published *Micrographia* in 1665, considered to be his greatest achievement. Using a microscope and his considerable artistic skills, he produced detailed illustrations never before seen. One of his most well known was that of a flea depicted in great detail, and another revealed that the eye of a fly is a compound eye made up of thousands of separate units. When studying a piece of thin cork, his use of the word 'cells' (as in a beehive) introduced the term into science for the first time. Samuel Pepys stayed up until 2 a.m. reading *Micrographia*, declaring it 'the most ingenious book I ever read in my life'.

Robert was the first to replace pendulums in clocks with springs and devised *Hooke's Law of Springs/Elasticity* (published in 1679), which remains relevant today. It states that the stretch of a spring increases in proportion to the force applied. Double one and

Robert Hooke. (© Rita Greer)

you double the other. His first pamphlet discussed capillary action and in 1661 was read to the society at Gresham. He became perpetual curate and a Fellow of the Royal Society in 1664 and was also Professor of Geometry at Gresham College, London.

It's thought that remnants of stone from Hooke's birthplace, the old farmhouse on Hooke Hill, were used in the construction of St Agnes Church, Freshwater Bay, the Isle of Wight's only thatched church (see 'Thatched Church of St Agnes Freshwater', p. 79). Sadly, the farmhouse became derelict and was demolished in 1908.

Robert Hooke was one of England's foremost scientists, philosophers and surveyors, whose teeming brain never ceased to marvel at the world and envisage new and futuristic ways of harnessing its wonders. As surveyor of London, he worked closely with his friend and colleague Christopher Wren in redesigning and rebuilding London after the Great Fire of 1666.

Hovercraft – The Last Remaining Hovercraft Service in the World

English inventor and engineer Sir Christopher Sydney Cockerell (1910–99) developed the hovercraft after experimenting with two empty cans, an air blower and a pair of scales, which revealed the number of weights that could be lifted using the air blower.

It eventually led to a vessel able to hover over rough ground and travel at speed on a cushion of air above the waves. Nicknamed 'a man-made flying saucer,' the hovercraft turned out to be one of the most successful inventions of the twentieth century. It was launched in the Solent in 1959 and known as the *SR.N1 – Saunders-Roe Nautical 1.*

The island's hovercraft, the longest running in the world, has been in service since 1965 and has 'flown' over thirty million people across the water and back. It's a thrilling sight to see it speeding onto Ryde Beach and turn to race over the sea back to Portsmouth. A one-way journey is a little less than 4 miles and takes around ten minutes.

Hovercraft, Ryde. (Photo Wendy Turner)

I

Irons, Jeremy

Jeremy John Irons was born in Cowes on 19 September 1948 and grew up in St Helens. He went to pre-school at Greylands in Bembridge and to prep school at Little Appley in Ryde. He learned to sail at the Brading Haven Yacht Club where his father was commodore. When he was thirteen his family moved to the mainland and he attended Sherborne School, Dorset, where his love of animals came to the fore, particularly horse riding. Before acting eclipsed all else, a career as a veterinary surgeon was in view.

Jeremy trained at the Bristol Old Vic Theatre School. His first appearance on the London stage came with *Godspell* (1973) and on Broadway in 1984 with Tom Stoppard's *The Real Thing*, for which he earned a Tony Award for 'Best Actor in a Play'. Jeremy is one of the very few to have achieved an Oscar, Emmy and Tony, the triple crown of acting.

Jeremy's film, theatre and television career rocketed with performances in classic roles such as Charles Ryder in *Brideshead Revisited* (1981) and Charles Henry Smithson in *The French Lieutenant's Woman* (1981). He delved into ever deeper and

Jeremy Irons. (© Jeremy Irons)

challenging roles: Pope Alexander IV in *The Borgias* (2011), Henry IV in *The Hollow Crown* (2012) and wartime prime minister Neville Chamberlain in *Munich* (2020). Shakespearean roles include *The Winter's Tale, Macbeth, Much Ado About Nothing, The Taming of the Shrew and Richard II*. In 2019, he returned to television as Lord of the Manor in the HBO series *Watchmen*. His was the voice of the villainous Scar in the Disney smash-hit film *The Lion King*.

Jeremy's charitable work encompasses The Prison Phoenix Trust, Action for Sick Children, Amnesty International, Sli Eile, The Prince's Trust, Greenpeace, T for Tibet, plus support for the homeless, blind people, mental health charities and endangered species, among many others. For four years he was chancellor of Bath Spa University.

Jeremy married actress Sinéad Cusack in 1978 and lives in England and Ireland.

Isle of Wight Festival

In the summer of 1970, Guinness World Records estimated that 600,000–700,000 festival-goers had congregated at Afton Down, Freshwater, to catch a glimpse of their idols at the annual five-day Isle of Wight Festival. The line-up included Joan Baez, The Moody Blues, The Who, Jethro Tull, The Doors and legend Jimi Hendrix. An Act of Parliament followed banning such large gatherings, and today the event welcomes around 70,000 people. The 1970 festival took place a mere couple of weeks before Jimi Hendrix's tragic death on 18 September 1970. A statue of him stands at the entrance to Dimbola, Freshwater (see 'Cameron, Julia Margaret', p. 17).

The festival resumed in 2002 in Seaclose Park, Newport. Headliners over the years include The Rolling Stones, David Bowie, Coldplay, Paul McCartney and Bruce Springsteen.

Jimi Hendrix, Isle of Wight Festival. (By kind permission, Dimbola Museum & Galleries)

J

'J'

When Charles I was held prisoner in Carisbrooke Castle he often wrote letters plotting his escape using his own secret code and signed with the letter 'J'. At the time, donkeys worked the treadmill, bringing up fresh water from the castle's well. Today, in Charles' honour, all the donkeys at Carisbrooke Castle are given names beginning with 'J', which have included Jack, Jill, Jigsaw and Jimbob.

Donkeys demonstrating in the wellhouse for visitors today have a much easier life. They turn the wheel twice only for around thirty seconds at each demonstration. When off duty, which is most of the time, they are groomed and cared for in their cosy stables or out grazing in the castle's 5-acre field.

Charles I coded letter. (© Carisbrooke Castle Museum Trust)

Jazz: Newport Jazz Club and Isle of Wight Jazz Weekend

Newport Jazz Club first sprang into life in 2010 when a group of jazz-loving friends put on jazz concerts at the Apollo Theatre in Newport. The sessions hit the right note with packed audiences, who regularly attend the Sunday concerts.

The club endeavours to put on a balanced programme. It has hosted a wide range of current UK jazz greats, with Digby Fairweather a regular visitor, and embraces all genres of jazz along with guest trad bands. It also showcases concerts for home-grown youth talent.

The Isle of Wight Jazz Weekend grew out of the success of the Newport Jazz Club. Its first weekend of concerts took place in 2012 and is now one of the major entries on the UK jazz calendar. Events are held at a variety of venues over the island, plus a well-attended fringe in smaller locations. The weekend hosts prominent UK and international artists such as Stacey Kent and has featured a number of big bands, including the BBC Big Band. It was also instrumental in the formation of the Isle of Wight Youth Jazz orchestra to encourage young musicians to take up playing jazz.

Digby Fairweather at NJC. (© Ian Mitchell)

Stacey Kent performing at the festival. (© Ian Mitchell)

Jigsaw Puzzle Festival: St James's Church, East Cowes

The island's first Jigsaw Puzzle Festival was put together in 1995 when the rector, Revd Stuart Cleaver, shared his love of puzzles by setting out his own collection. They were joined by many other puzzles and around eighty were sold. The idea blossomed into today's Jigsaw Puzzle Festival, held in the second full week of August.

Today's festival sees puzzles displayed around the whole body of the church by enthusiastic volunteers who complete them throughout the year. Around 300 are displayed at any one time, with replacements put out as soon as one is sold. Thousands of puzzles have been sold over the years, making the event a successful fundraiser.

Puzzles cater for all ages and tastes and range from those suitable for babies and children to traditional country scenes and the latest 3D, double-sided, murder mystery and wasgij (jigsaw spelled backwards) where only a clue to the whole picture is given on the front of the box. There are also impossipuzzles where an image is repeated many times over, as in beans or sprouts.

With everything now nicely boxed up since the rector first put all the pieces together for a successful event, the Jigsaw Festival continues to be a popular annual happening.

Jigsaw Festival. (© St James' Church, East Cowes)

Jousting

Where might you come across the Wyvern, the Wildman, Sir Lancelot and Jason of the Argonauts? The four mythical beings, represented by four highly trained knights on thunderous and magnificent horses, battle for the crown of honour and glory at the Legendary Joust on the Bowling Green at Carisbrooke Castle every August, organised by English Heritage.

The joust brings with it a slice of medieval life, with the sights, sounds, aromas, stories and merry music of the time. There's also a falconry display, fire shows from the castle jester and a whole host of medieval characters sharing their cookery and craft skills. Children can try their hand at hobby-horse jousting while enjoying medieval fun and games.

Jousting. (© English Heritage)

Kathleen Riddick OBE

'If music be the food of love, play on.' So says Duke Orsino in Shakespeare's *Twelfth Night*. The quote could well apply to Kathleen Riddick (1907–73), born in Epsom to Isle of Wight parents. Her father, Charles, son of Brading mayor William Riddick, was an operatic singer who also played the double bass. Her mother, Kate Day, was born in Bonchurch and was a professional pianist. Aged four, Kathleen learned piano with her mother. She went to school in Ventnor and at the age of ten started learning the cello.

Kathleen won a scholarship to the Guildhall School of Music and Drama (GSMD) in London to study cello, piano and composition. After graduating, she pursued a career playing the cello. She made her first broadcast as a member of the Sarre Piano Trio, performing Saint-Saens' First Cello Concerto with the Isle of Wight Symphony Orchestra.

Kathleen's dream of conducting became reality when at the age of fourteen she conducted an Epsom amateur orchestra, but as a woman she was barred from studying conducting at the GSMD. Undaunted, she enrolled on the International Summer Conducting course at the Mozarteum in Salzburg in 1937, and on her return formed the London Women's String Orchestra, the first professional women's orchestra in Britain. Their opening concert in London was acclaimed a spectacular success and frequent broadcasts followed. The orchestra became the Riddick String Orchestra, and then the Riddick Orchestra.

During the Second World War, when many male musicians joined the armed forces, Kathleen's orchestra performed classical music concerts for BBC radio. They also toured Britain, their music helping to lighten hearts during those anxious years. Concerts were held in Ryde Town Hall where the orchestra played works by Bach, Vivaldi, Elgar and Greig.

In 1943, Kathleen conducted the BBC Orchestra. She became the first woman to conduct the BBC Northern Orchestra (now the BBC Philharmonic) and the BBC Scottish Orchestra. She also conducted the London Symphony Orchestra. In 1951, she was the first woman to conduct an orchestra at the Royal Festival Hall with her amateur orchestra, the Surrey Philharmonic.

Kathleen married musician George Bixley in 1934. She continued teaching and in 1961 received an OBE for services to music. She died at her home in Ashtead, Surrey, in 1973. Her fondly named 'Surrey Phil' lives on, still performing today.

Kathleen Riddick OBE. (© Susan Bixley)

Kathleen had a generous nature and loved to encourage other woman performers. She championed contemporary music and gave early and first performances of works by many composers, including Arthur Bliss, Benjamin Britten and Vaughan Williams.

Against all the odds, the little girl from Ventnor achieved sparkling success in a field she loved and loved to share.

Keats, John

English Romantic poet John Keats (1795–1821) lived on the Isle of Wight between 1817 and 1819 in Castle Road, Carisbrooke, and Eglantine Cottage (now Keats Cottage), Shanklin. He loved to wander freely across the downs and ponder the haunting power of the sea, which inspired some of his greatest poems.

Keats came to the Isle of Wight seeking peace and inspiration to write *Endymion*, based on the Greek love story of Endymion and the moon goddess Selene (Cynthia). Pale Selene rose from the sea at night and sailed across the dark sky, radiating her soft light. She fell in love with a mortal, Endymion, the shepherd/hunter, and the night sky lost its light as Selene left the heavens to spend more time with her beloved. Endymion eventually embraced an eternal sleep to preserve everlasting youth. The poem's first line, 'A thing of beauty is a joy forever', was written on Bowcombe Down.

Keats was born in 1795, the eldest of four children. He studied to become a surgeon but his love of nature, the outdoors and literature, particularly Spenser's *Faerie Queene*, awakened in him a true love of poetry. *Endymion* was divided into four books of around 1,000 lines each.

Keats, suffering from consumption (TB) went to Rome for its warmer climate. He died aged just twenty-five and was buried in Rome's Protestant Cemetery. No name graces his tombstone, but, inscribed at his own request, are the words 'Here lies One Whose Name was writ in Water'. Keats, passionate about the works of Shakespeare,

K

John Keats. (© Wellcome Collection)

may have come across the words in the play *King Henry VIII* (Act IV, Scene 2) where Queen Katharine's gentleman usher, Griffith, observes: 'Men's evil manners live in brass: their virtues we write in water.'

If Keats felt that his short life and works would be little remembered, it's a joy to know that he is among the most studied and quoted of our English lyric poets. The first line of *Endymion* is still widely used today, not least in the films *Mary Poppins* and *Willy Wonka and the Chocolate Factory*.

King!

You could be forgiven if the name of Henry de Beauchamp doesn't ring a bell, but during the fifteenth century legend has it that the monarch, Henry VI, bestowed the title 'King of the Isle of Wight' on Henry, his long-time friend. Nobleman Henry de Beauchamp became 1st Duke of Warwick (1425–46). Sadly, there is no evidence that he visited the Isle of Wight, but perhaps he is remembered on the signs of The Bugle public houses. 'Bugle' in the language of the time, referred to a young bull, thought to have been the symbol adopted by the young king. Its roots are in the Latin *būculus* meaning 'a young bullock'. A story buried in the mists of time, but an engaging one.

L

Lifeboats: Royal National Lifeboat Institution

The RNLI provides a twenty-four-hour on-call lifeboat search-and-rescue service around the shores of the UK and Ireland, and a lifeguard service during the summer season. Lifeboats on the island are stationed at Bembridge, Cowes and Yarmouth.

There are two categories of RNLI lifeboats: the all-weather and inshore. Various classes of lifeboats within the categories take into account the likely needs of different situations plus local geographical features. The Shannon class all-weather lifeboat has a crew of six and capacity for 102 survivors. The maximum speed is 25 knots and the range 250 nautical miles. It is ideal for offshore search and rescue in all weathers with enough power to tow large boats, and also holds a small daughter boat to help carry out rescues in shallow water or near rocky coasts. The inshore lifeboat has a crew of two to four with a survivor capacity of five, a maximum speed of 40 knots and an endurance of three to four hours at maximum speed. It is an inflatable lifeboat designed to operate in shallower water and used for rescues in the surf, near shore, on rocky coasts and cliffs and for cave rescue. Searchlights and flares are essential for night-time rescues, which contend with the obvious dangers of rocks, cliffs and caves, and man-made structures at night. 'Shouts' for 2021 were 120 for all three stations.

Lifeboat at Yarmouth Harbour. (By kind permission)

M

(St) Mildred's Church, Whippingham

St Mildred was an Anglo-Saxon princess who died circa AD 700. She shunned her nobility and offers of marriage and became known for her compassion for the poor. She was drawn to the religious life and entered minster on the Isle of Thanet, where she eventually succeeded her mother as abbess. Her feast day is celebrated on 13 July.

Queen Victoria and her family worshipped at St Mildred's Church when staying at Osborne House. The chancel was rebuilt in 1854–55 by Albert Jenkins Humbert, an architect much favoured by Prince Albert, who also had an input into the design. Building work was completed by 1862, resulting in today's magnificent church.

In 1885, Princess Beatrice, youngest child of Queen Victoria, married Prince Henry of Battenberg at St Mildred's Church. She wore a sumptuous, fitted wedding dress

St Mildred's Church, Whippingham. (Photo Wendy Turner)

decorated with garlands of flowers, and her mother's tumbling veil of Honiton lace. A crucifix nestled at her throat, she held a lacy fan. Henry wore his white military uniform complete with a sword, while the queen was dressed in her usual black mourning. The couple honeymooned at Quarr Abbey House, the home of the princess's lady-in-waiting, Dame Anne 'Minna' Cochrane. Sadly, Prince Henry died after barely ten years of marriage of malaria while away at the Ashanti War on the Gold Coast after persuading the queen to release him from his duties as governor of the Isle of Wight. He lies in the Battenberg Chapel in an elaborate marble tomb surmounted by a sword. Princess Beatrice died in 1944 and was buried with him at the end of the Second World War (see 'Princess Beatrice, Governor of the Isle of Wight', p. 63).

The royal pew at the church was part of the 1854 rebuild of the chancel to provide a private area for the family.

The war memorial was unveiled by Princess Beatrice as governor of the Isle of Wight at the end of the First World War. The connection is personal as her youngest son, Maurice, died at Ypres. His is the first name on the list of those who died.

The church, appropriately situated in Beatrice Avenue, is one of the outstanding places to visit on Queen Victoria's Island trail (see 'Victoria's Island Trail', p. 83).

Museum of Ryde and the Donald McGill Postcard Museum

In 1941, writer, journalist and critic George Orwell published his essay *The Art of Donald McGill*. Donald McGill's name may not be immediately familiar, but his popular postcards may well be. They portrayed cheeky young things, obese mothers-in-law or wives in curlers brandishing a rolling pin, among many others. Thousands were sent by people away on holiday to friends and family and were sure to raise a smile.

In the somewhat moral 1950s, McGill's cheeky art was frowned upon and a crackdown ensued. Bundles of his postcards were seized and destroyed by police, who were often the butt of McGill's jokes. Shops were raided across the country, with some 5,000 cards destroyed in Ryde alone. It ended in a trial in 1954 under the 1857 Obscene Publications Act. McGill argued his case that no *double entendres* were intended in his artwork, but he was fined nevertheless.

In his essay, George Orwell pondered the genre of the English saucy postcard and observed: 'McGill is a clever draughtsman with a real caricaturist's touch.'

Throughout his career of over fifty years, Donald McGill produced thousands of different artworks for his comic and social postcards, with an estimated 200 million being sold. *Punch* magazine described him as 'the most popular, hence most eminent English painter of the century'.

The Donald McGill Postcard Museum was opened in 2010 by Mr Patrick Tumber, grandson of Donald McGill, as part of the Museum of Ryde, where you can revel in all things Ryde and marvel at the museum's unique ice well, part of the original Arcade.

Above left: George Orwell. (Photo Branch of the National Union of Journalists 1933)

Above right: Donald McGill. (© Mr P. Tumber)

Ceiling detail, Museum of Ryde. (Photo Wendy Turner)

National Poo Museum

Despite its somewhat bizarre name, the National Poo Museum uses interesting facts and gentle humour to bring to light new findings from insect, animal and human droppings, leading to a better understanding of the science of gut bacteria. The museum displays a unique collection of (sealed!) exhibits, including fossilised crocodile droppings from twenty million years ago and from dinosaurs that roamed the island 120 million years ago.

The museum was founded by Daniel Roberts (see 'Xylophone Fence', p. 89) and a collective of artists in 2016 as a mobile facility, but now has a permanent home at Sandown Barrack Battery, one of the Palmerston Forts originally built as coastal defences and named after Lord Palmerston, prime minister in the mid-1850s.

National Poo Museum, Sandown Barrack Battery. (By kind permission)

National Poo Museum with founder Daniel Roberts. (By kind permission)

The museum invites you to discover why various insects find it advantageous to disguise themselves as poo and how a mammal manages square droppings. To keep you flushed with interest, you could try some of the interactive exhibits and learn more about ancient Roman sewer gods. 'Have you been?' the museum asks.

Needles, the

It's difficult to imagine anything but sweeping winds disturbing the picturesque headland near the Needles, but during the First World War the German submarine *UB35* sank two ships at the location. The first, armed escort ship SS *Mechanican*, sank when two torpedoes tore through its hull. Thirteen crew lost their lives. Two days later, *UB35* torpedoed SS *Serrana*, an armed merchant ship. There were only two survivors.

'The Needles' – three chalk rocks jutting out of the sea near Alum Bay – are one of the island's most iconic, visited and photographed sites. There were once four rocks. The missing one was needle-shaped and also the tallest. It crumbled during a violent storm in 1764 and became fondly remembered as 'Lot's Wife', who according to the Book of Genesis, was turned into a crumbling pillar of salt when she looked back at the burning city of Sodom. By then the Needles had become well known and the name stuck. Cliffs at the Needles were used for troop training prior to the D-Day landings and, in the mid-1900s, a secret rocket and missile centre was established at

the Needles Old Battery (see '*Black Arrow*', p. 13). Today, a breathtaking chairlift will take you down to Alum Bay (see 'Alum Bay', p. 7).

The lighthouse braving the elements at the outer end of the Needles was built by Trinity House in 1859 at a cost of £20,000. Its lower granite sides are 3 feet thick so as to withstand the constant pounding of the sea, and its light can be seen for 17 miles. Today the lighthouse is fully automated and is a guiding light for shipping in the Solent, with an emergency helipad on top. You can take a boat trip around the Needles and the lighthouse from Alum Bay or Yarmouth Harbour.

In 1897, the renowned Italian inventor and electrical engineer Guglielmo Marconi experimented with radio transmissions from the Needles to ships out at sea. Two years later he established wireless communication between France and England, and then across the Atlantic. He was awarded the Nobel Prize for Physics in 1909. You can see his monument at the Needles, which marks the precise location of his pioneering work, the root of today's radio and telecommunications. In 1912, Marconi's wireless system aboard *The Titanic* was deployed by the distressed crew, which helped to save the lives of over 700 people.

The Needles are one of the Royal Geographical Society's top seven natural wonders of Britain. The site is managed by the National Trust and gives visitors a taste of life on the battery during the Second World War.

The Needles. (Photo Ray Wilkinson)

O

Old Girl – The Island's Wonder-Bus!

Old Girl, the island's oldest bus, celebrated eighty years of service in 2019. It began life as a double-decker in 1939 at the start of the Second World War and has been busy transporting passengers ever since. It had a fine makeover in 1959, which transformed it into an open-top sightseeing bus, chugging along at a top speed of 30 mph from Shanklin to Ventnor. It then found its way onto the Needles Breezer route until 1999.

The bus, a British-made Bristol K5G, is lovingly maintained in semi-retirement by Southern Vectis, keeping its tan leather benches, hop-on hop-off platform and winding staircase in good shape for private events. It celebrated eighty years with a vintage tea party and music at Ryde bus station, which also raised funds for the island's branch of the British Legion.

Old Girl Bus. (© Southern Vectis)

Osborne House, East Cowes

'It is impossible to imagine a prettier spot.' (Queen Victoria speaking of Osborne House)

You could be forgiven for thinking you had wandered into a little piece of Italy at Osborne House.

Queen Victoria had fond memories of the Isle of Wight from childhood and, as her family grew, she and Prince Albert felt the need for a retreat. They found the perfect estate at East Cowes, with an existing three-storey Georgian house. Soon, however, more space was needed and the old house was demolished; only a doorway remained, and this was reused as the entrance to the walled garden. It made way for Prince Albert's new Italian design in conjunction with London architect Thomas Cubitt, whose company had built the façade of Buckingham Palace. The warm, cream-coloured building, built between 1845 and 1851, features a clock tower and flag tower, columns and arches, sculpted gardens and flower beds, shady walkways, terraces, classical statues and fountains. It was a favourite of the queen and her family. They visited whenever they could, especially in times of celebration.

Funds for new furnishings were raised from the sale of Brighton Royal Pavilion to the city of Brighton. Formal rooms were located on the ground floor, but upstairs was more comfortable with the family's private bedrooms and dressing and sitting rooms and the all-important nurseries. Further additions were made to the house over time, not least the wing built between 1890 and 1891, designed by John Lockwood Kipling, father of the poet Rudyard Kipling. The family enjoyed swimming from nearby Osborne Bay where the queen kept her bathing machine – her private changing room. Similar to a wheeled cabin, it had a front porch, curtains and private facilities.

The children were provided with a life-sized Swiss cottage in the grounds, once believed to have been transported from Switzerland but now thought to have been built on the estate. They grew fruit, flowers and vegetables in their own little plots of land and sold them to their father at market price, which taught them basic housekeeping. They also learned to cook in the cottage kitchen and made afternoon tea for their parents, serving their home-made pastries and biscuits. Their individual wheelbarrows and gardening tools can still be seen in the shed.

Queen Victoria died at Osborne House on 22 January 1901. Her coffin was placed on a horse-drawn gun carriage for the journey to East Cowes, where it was transferred to the royal yacht *Alberta* and the onward journey to London. Her bedroom remains as she left it. A portrait of Albert lies on his pillow and the little silk pocket for his watch (a replica as the original is fragile and in storage) hangs on the headboard. After the queen's death only Princess Beatrice and Princess Louise continued to live on the estate, and in 1902 Edward VII presented it to the nation on his coronation day.

The King Edward VII Convalescent Home at Osborne House opened in 1904 and closed in 2000. It treated casualties from the African wars and the two world wars. The poet Robert Graves noted in *Goodbye to All That*:

O

I was sent to a convalescent home in the Isle of Wight – none other than Osborne Palace; my bedroom had once been the royal night nursery of King Edward VII and his brothers and sisters ... We patients could take all Queen Victoria's favourite walks through the woods and along the quiet seashore

The filming of *Victoria and Abdul* took place at Osborne House in 2016, following which Dame Judi Dench became the first Patron of Friends of Osborne. It is managed by English Heritage and welcomes around a quarter of a million visitors every year.

Right: Osborne House. (By kind permission)

Below: Grounds of Osborne House. (By kind permission)

Paddle Steamer *Medway Queen* – From Medway to Medina

The paddle steamer *Medway Queen* started life in 1924, taking passengers on pleasure trips across the Thames Estuary. It was requisitioned in 1939 for the Second World War and converted to a minesweeper, becoming HMS *Medway Queen*. It continued helping to keep the seaways clear and, like many other vessels, responded to the call and took part in *Operation Dynamo* in late May 1940, rescuing desperate Allied troops being pushed back and attacked by the German army at Dunkirk. Thousands of men were trapped on the soft and shallow beaches, which even at high tide meant that no destroyers or other large ships could draw near. Hundreds of small vessels of all types, not least fishing vessels, riverboats and lifeboats, some crewed by

Paddle steamer HMS *Medway Queen*. (© Bob Tebbutt, Chris Tebbutt)

volunteers, crossed the Channel and ferried the men from shore to ship or brought them back themselves, all the while under intense German attack. HMS *Medway Queen* made seven return trips, rescuing thousands of troops. Over 338,000 men were saved in all, including over 224,000 British soldiers, in what turned out to be the greatest evacuation in military history. Many vessels, large and small, crossed the Channel continuously and under perilous conditions. Inevitably, dreadful losses were sustained.

After the war, the ship returned to its days of excursions, but paddle steamers began to lose their appeal and it was withdrawn in 1963. In 1965, it came to the Isle of Wight and opened the following year as the Medway Queen Club, serving as a popular restaurant, nightclub and wedding venue. Live bands lit up the evenings for the next eight years or so. When those happy days ended, the ship languished in the River Medina until it was rescued in 1984 and moved to Chatham, Kent. The Medway Queen Preservation Society was formed in 1985 to support its restoration and fought for its preservation, becoming the boat's owners in 1987. Success came when its hull was wholly rebuilt in Bristol between 2009 and 2013 with the support of the Heritage Lottery Fund and the European Regional Development Fund.

You can visit the famous paddle steamer and explore its remarkable and moving history at Gillingham Pier, where it is moored for continuing restoration.

'Pepperpot': St Catherine's Oratory – Fourteenth-century Lighthouse

St Catherine's Oratory (chapel) stands tall and stark, high on St Catherine's Hill on the southern tip of the island. Its remarkable story reaches back to 1313 when a ship transporting barrels of white wine to a French monastery ran aground in the dangerous Chale Bay. Local people flocked to the beach where the precious cargo was being hastily sold off. Much of the wine (it's thought over fifty barrels) found its way to the vaults of the lord of the manor of Chale, Walter de Godeton. The ship was from Gascony, then part of the kingdom of Edward II, and Walter was deemed to have stolen church property. The incident came not only to the ears of the king, but to those of the pope, Clement V. Under threat of excommunication, Walter was compelled to build an oratory and beacon dedicated to St Catherine as a penance, although it's thought he may simply have provided funds to maintain an existing chapel. He also funded priests to keep the beacon alight with prayers for those lost at sea, an arrangement that continued for over 200 years until Henry VIII's Dissolution of the Monasteries.

The oratory became known as 'The Pepperpot'. Its rocket-like appearance is due largely to the addition of buttresses to support the structure in the eighteenth century. Parts of the old walls and the outline of the original building, of which the oratory forms a part, can still be seen.

'The Pepperpot', Milky Way over St Catherine's Oratory. (© visitisleofwight.co.uk)

The Pepperpot is considered Britain's best-surviving medieval lighthouse, although it may originally have been a bell tower and beacon. It is cared for by the National Trust in partnership with English Heritage.

PLUTO – Pipe-Line Under the Ocean

It was Lord Mountbatten, Chief of Combined Operations, who came up with the idea of PLUTO (Pipe-Line Under the Ocean), the project that piped fuel from Shanklin Chine and Sandown to Allied troops during the Normandy invasion in 1944. The challenge

PLUTO plaque. (© Peter Trimming)

was to overcome the immense and unknown difficulties of running a pipeline under the sea to Cherbourg. Success was achieved, thanks to brilliant engineering and dogged determination. A massive 56,000 gallons a day was conveyed until the Allies advanced and a new route was needed, which ran from Dungeness in Kent. From there, a million gallons per day arrived in Boulogne and even as far as the Rhine. You can see a cross-section of the pipeline in Shanklin Chine's Heritage Centre and read the full story in Adrian Searle's *PLUTO*.

Princess Beatrice, Governor of the Isle of Wight

Princess Beatrice (1857–1944) had a longstanding association with the Isle of Wight, having spent much of her life as companion to her widowed mother, Queen Victoria. She was the youngest child of the queen and Prince Albert and, as her mother's favourite, the queen was reluctant to allow her to marry her sweetheart, Prince Henry of Battenberg. Agreement was reached on condition that after their marriage the couple lived with the queen. They married in 1885 at St Mildred's Church, Whippingham, near Osborne House, and their neighbour, Alfred Lord Tennyson, penned a special poem to mark the occasion. Beatrice and Henry had four children, but tragedy struck in 1896 when Prince Henry died of malaria while on his way home from the Anglo-Ashanti War, aged just thirty-eight. On his death, Beatrice acceded to his role as governor of the Isle of Wight, conferred upon Henry by the queen.

Beatrice lived at Osborne Cottage but made her summer home at Carisbrooke Castle, the traditional residence of the island's governor. She added a bathroom and other home comforts and opened the Memorial Museum in the gatehouse, which had been restored in the late 1800s by architect and historian Percy Stone and dedicated to Prince Henry. Beatrice also advocated restoration of the Chapel of St Nicholas and gave the altar painting in memory of her youngest son, Maurice, who died at Ypres in 1914. The museum's collection gradually expanded, and in the 1950s it was relocated to the former governor's house, which became the Carisbrooke Castle Museum.

During her time as governor, Beatrice took comfort from walking in her private (privy) walled garden. In 2009, English Heritage, with renowned garden designer Chris Beardshaw, former presenter of BBC's *Gardeners' World*, recreated the Princess Beatrice Garden. The garden, inspired by Beatrice's original garden, is in geometric style and reflects the times and governorship of Princess Beatrice and the history and architecture of the castle.

Princess Beatrice died in 1944 aged eighty-seven at her home in Brantridge Park, Sussex. She and Henry are both buried in St Mildred's Church (see '(St) Mildred's Church, Whippingham', p. 51).

Prison – HMP Isle of Wight

The present prison building north of Newport began life as a military hospital in 1778. In 1838, it was converted to an institution for the education and training of young male offenders for onward transportation to Australia or New Zealand, where their behaviour and progress in prison was reflected in their status on arrival in the new country. Gradually, attitudes changed and prisoners began to be released into the UK. HMP Isle of Wight was established in 2009 after a merger of Parkhurst, Albany and Camp Hill, and accommodates over 1,000 detainees.

The famous identical twins Ronnie and Reggie Kray also spent time here. Their lives of organised crime in London's East End were portrayed on the big screen in the gangster film *The Krays* (1990) starring Spandau Ballet brothers Gary and Martin Kemp, who had previously visited Ronnie Kray in Broadmoor for an insight into their roles.

Quarr Abbey, Ryde – Abbey of Our Lady of Quarr

Quarr Abbey is a working Benedictine monastery. The unusual name comes from the nearby quarries and pits and was the name of both the old and new abbeys of Quarr.

The abbey is the daughter house of the monastery of Solesmes, whose monks were forced into exile by the anti-clerical laws of France in 1901. Most communities went to Belgium, but Solesmes was among those that came to England, settling first at Appuldurcombe House, near Ventnor. When the lease expired, a permanent home was sought and the monks purchased Quarr Abbey House, a mere 300 yards from the ancient Quarr Abbey. Speedy building work, in attractive shades of Belgian red and yellow brick, went ahead under architect Dom Paul Bellot, whose concept was to create a vision of light around the abbey's interior. Within ten and a half months the first phase of a new monastery was completed, which included the monastic cells, the refectory, the library, the chapter house and three sides of the cloister. In 1908, Abbot Delatte suitably thanked the workers by hosting dinner for them in Ryde Town Hall. The abbey church was consecrated in October 1912 and the title of 'abbey' restored in 1937.

The ancient Quarr Abbey was founded in 1132 from Savigny by Baldwin de Redvers, Lord of the Isle of Wight and Earl of Devon, and consecrated in 1150 having been aggregated to the Cistercian Order in 1147. During the Hundred Years' War (1337–1453) Abbot William set about protecting the abbey, made vulnerable by the proximity of the naval bases of Portsmouth and Southampton, by erecting sturdy enclosure walls and battlements. Monastic life continued at Quarr for 400 years until Henry VIII's Dissolution in 1536.

Today, a beautiful walk leads to the substantial old ruins overlooking the sea. On the way, it's a joy to stop and admire the abbey's pigs, piglets and lambs before passing on to the beautiful woodland walk, home to rare bats and orchids and the island's famed red squirrels. The clover-rich meadow provides pollen and nectar for bees in the abbey's many beehives.

During the First World War the guesthouse became a place of convalescence for wounded officers. It was visited by Princess Beatrice, Governor of the Isle of Wight,

Quarr Abbey, Ryde. (By kind permission)

and poet Robert Graves was a patient for a time. He wrote of his stay in *Goodbye to All That*:

> I made friends with the French Benedictine Fathers who lived nearby ... and admired their kindness, gentleness and seriousness ... and meals eaten in silence at the long oaken tables, while a novice read *The Lives of the Saints*. The food, mostly cereals,

Livestock at Quarr Abbey, Ryde. (By kind permission)

vegetables and fruit, was the best I had tasted for years – I had eaten enough ration beef, ration jam, ration bread and cheese to last me a lifetime.

Monks at Quarr undertake a variety of tasks. The 'Work of God', the celebration of the seven daily services, has pride of place. They also offer retreat facilities in the abbey's guesthouse. The intern programme offers men between the age of eighteen and twenty-five the possibility of living in the monastery for eight weeks, following a way of life similar to that of the monks. Home-grown produce is served in the café farm shop and tea garden where a host of garden birds abound, and you can also buy locally produced preserves, honey, chutneys, cheese, organic fruit, vegetables and abbey ale. During the Second World War, the island's emergency food supply was stored in the abbey's cellar.

Visitors are welcome to join one of the seven daily services where the Gregorian chant is sung. You can check the schedule with the cloister clock in the new visitor centre, which tells of the monks' hourly routine.

The monastery follows the Rule of St Benedict (*c.* 480–547), whose feast day is celebrated on 11 July. The mottos of the Benedictine Order – 'peace' and 'may God be glorified in everything' – extend to all in this hallowed and sacred place.

Old Abbey at Quarr. (By kind permission)

R

Ramblers IoW: Donate a Gate

The Isle of Wight Ramblers has around 450 members in two groups to suit all walkers, from short strolls to invigorating hikes over the downs. Some explore the beauty of the island from coastal paths with spectacular views; others follow less well-known paths to creeks, woodlands and nature reserves. Dedicated ramblers tackle the three-day round-the-island walk.

'Donate a Gate'. (© IoW Ramblers)

Around seventy walks can be freely downloaded from the website, where you can view the ramblers' own local books, maps and Perry's Guide, with all footpaths marked with their parish and town numbers. The Isle of Wight Ramblers successfully campaigned to be included in the 3,000-mile-long England Coast Path.

The ramblers strive to make the island's countryside as accessible as possible. As stiles are not suitable for everyone, they came up with their 'Donate a Gate' scheme, where a replacement footpath gate is installed, paid for by people who wish to commemorate a loved one or a special event. Over 230 gates have been installed, each with an inscribed plaque. The scheme is supported by the Isle of Wight Council and the National Trust.

Paths Representatives and volunteers get involved in many ways, supporting the council team who ensure that paths are kept unobstructed and are well signed from the highway. They also help with larger tasks, such as replacing steps and boardwalks.

Isle of Wight Ramblers are very involved with the local community and are passionate in caring for the countryside.

Randonnée IoW

The Randonnée, a free-to-enter event that raises funds for local charities, was established by the Wayfarer Cycletouring Club in 1985 and is organised by Cycleisland Community Interest Company (CIC). Over 2,500 people turn up each year and choose the 100-km or 55-km route.

The action takes place from 9 a.m. to 6 p.m. on the early May bank holiday weekend. It offers cyclists a chance to get out and about and explore the island in a relaxed and family friendly way. The waymarked 'Round the Island' (RTI) routes take in pretty, smaller roads and lanes where possible, enabling cyclists to enjoy the island's quieter places as well as the more spectacular. The Taste RTI Cycle Route highlights tasty stopping places along the way.

Red Squirrel Trail

The Isle of Wight's cherished red squirrels are generally protected by the barrier of the Solent. They live on cones and seeds and shelter in the island's broadleaved and rich ancient woodland, which can accommodate around 3,500 squirrels. Food is plentiful due to lack of competition from grey squirrels and deer, and they boost winter food stocks by burying seeds and fruit when abundant.

Red squirrels, easily identified by their colour and unique ear tufts, grow to approximately 20–22 cm plus a tail of 18 cm. Adults weigh around 300 grams and live up to six years. They nest in dreys made from moss and leaves and utilise tree holes for their young. They are good swimmers too, using a doggy paddle and their tails as rudders.

A–Z of The Isle of Wight

You may well spot a red squirrel at Parkhurst Forest (near Newport), Rylstone Garden, Shanklin, Alverstone Village and at Quarr Abbey. You can also follow the 32-mile Red Squirrel Trail from East Cowes to the coast at Shanklin and Sandown.

Red squirrels and their dreys are protected under the Wildlife & Countryside Act 1981.

Left: Red squirrel. (© Helen Butler MBE)

Below: Red squirrel at Shanklin. (Photo Ray Wilkinson)

Roman Villa

If a beautiful and ancient mosaic floor depicting a multitude of gods, goddesses, muses, flora and animals is for you, look no further than Brading Roman Villa, inhabited and thriving between AD 50 and 400. The exquisite mosaic floor, among the finest in northern Europe, dates to around the fourth century AD when the new villa was built, home to the affluent estate owner and his family.

Discovery came in February 1879 when a farmer, Mr Munns, hammered a spike into the cold winter ground to build a sheep pen and struck the mosaic of a cockerel-headed man. Brading archaeologist Captain Thorp was called and soon the first room was discovered. Corrugated-iron housing was constructed to protect the precious mosaics and Roman remains.

The Romans chose the perfect location for their villa. The soil was well drained and the site protected by the chalk downs. There was a plentiful supply of fish, shellfish, sea birds and salt in the ancient estuary and evidence suggests a range of crops was grown and farm animals reared. With fresh water springs and an abundant woodland nearby, the location, now an Area of Outstanding Natural Beauty, was an ideal choice.

The museum opened in 2004 and preserves the West Range, the main building. You can still see the hypocaust (the underfloor heating system) and the foundations of the earlier North and South ranges outlined in chalk outside the museum. Evidence of burning suggests the villa may have been destroyed by fire.

The land and museum site are owned by The Oglander Roman Trust, who were instrumental in creating the charitable trust to manage Brading Roman Villa, together with the Friends of Brading Roman Villa. There is much more to be discovered and perhaps a new generation of archaeologists will throw further light on the Roman past of the island.

Brading Roman Villa is a Scheduled Ancient Monument and Grade I listed building.

Brading Roman Villa. (By kind permission)

S

Scarecrow Festival: 'the Gallybaggers'

A hundred or so scarecrows pop up in and around the gardens of the parish of Chillerton and Gatcombe during the Scarecrow Festival, which has been running every other year since 2010 in the May half-term. You can vote for your favourite 'Gallybagger' over coffee and cake in the village hall, otherwise known as Aunt Sally's Tea Room, or at the Gallybagger Inn. Over a thousand visitors flocked to the festival in 2022, who between

'The Undersea Divers', Scarecrow Festival. (© Chillerton and Gatcombe Community Association)

'The Gruffalo', Scarecrow Festival. (© Chillerton and Gatcombe Community Association)

them cast 885 votes declaring 'the Undersea Divers', 'the Gruffalo' and 'the Queen in her Carriage' splendidly superb scarecrows. Rosettes are awarded to the top three, and the winner is awarded the coveted cup. Proceeds go to local good causes.

Shanklin Chine

For a stunning walk amid overhanging trees, exotic wildflowers, abundant wildlife, cascading waterfalls and little half-hidden paths and bridges, look no further than the historic gorge (a deep, narrow ravine) at Shanklin Chine. You can walk through the gorge to the beach from Shanklin Old Village and take in nature at its best. Victorian curiosities abound on the way, including stocks where petty crooks suffered both physical and verbal abuse, and a Victorian hot brine bath, once credited with special healing properties.

The Chine opened in 1817 and soon became a visitors' favourite, not least of Queen Victoria, John Keats, Charles Dickens and Jane Austen. Its shady depths were also favoured by smugglers, so much so that sharp-eyed excise officers lodged in Shanklin

Above left: Steps at Shanklin Chine. (Photo Ray Wilkinson)

Above right: Waterfall at Shanklin Chine. (Photo Ray Wilkinson)

Old Village. During the Second World War the Chine was used by the Commandos as an assault course.

The Chine is a charitable trust and has a heritage centre and a Victorian tea garden. You can find out more about its diverse flora in the Nature Trail leaflet.

Stargazing – Isle of Wight style

As the island is a UNESCO Biosphere Reserve with low light pollution levels, it's the perfect place to study the night sky. There's a wide choice of locations, from the downs to coastal areas, well away from illuminated towns and roads. Viewing is best in winter, spring and autumn, and at the new moon when there is little natural brightness in the sky.

The Plough or Big Dipper is among the most well known, with seven of the brightest stars, part of the Ursa Major (Great Bear) constellation. The 'W' of Cassiopeia is also easily identifiable, as is the Milky Way and the three stars in the Belt of Orion (the hunter), with the dog Sirius, the brightest star in the sky, at his feet. You can plan ahead by using the Sky Astronomy Calendar of Celestial Events to pinpoint comets, eclipses, meteor showers and solstices.

Steam Railway

It's a pleasure to step back in time and take a tour on the Heritage Steam Railway. You could travel in the lovingly restored Victorian and Edwardian carriages, dating back to 1864, with the railway's oldest locomotive, built in 1876. The trip takes an hour

S

or so, running from the main station at Havenstreet to Smallbrook Junction, and then non-stop to Wootton and back to Havenstreet. Three hours is recommended to sample everything on offer.

Steam train special events include Heritage Train Day, Spring Gala, Festival of Transport, Real Ale Train, Cider and Cheese Festival, Summer Concert, Race the Train along 5km between Wootton and Havenstreet, Wizard Week, a Teddy Bear special, plus a 40s experience with live music and 40s food. You could turn up in vintage clothing and glam-up with a 40s hairstyle at the on-site hairdresser!

The Heritage Steam Railway is a registered educational charity and celebrated its 50th anniversary in 2021. It has appeared on numerous TV and film productions including *Great Railway Journeys*, *Blue Peter*, *Lady Chatterley* and *Grange Hill*.

IoW Steam Railway. (Photo Ray Wilkinson)

Steam train on the move! (Photo Ray Wilkinson)

Swifts

The annual Swift Awareness Week takes place around June and July. News, sightings and knowledge are shared in a bid to reverse swift decline and better understand the breeding population, taking account of the need to conserve existing nesting sites and incorporate swift-friendly projects around new buildings.

Swifts come to the Isle of Wight from West Africa each summer to breed, staying for three months or so. With much of their lives spent on the wing, it's estimated that they can make the journey in just five days, travelling up to 70 mph.

Swifts breed from the age of four onwards, when they pair and seek out previous nests. They will eventually return to West Africa, taking their new offspring with them. The glorious high-pitched call of high-flying swifts is a well-loved indication of summer coming.

Swifts. (© Richard Crossley)

Tennyson, Alfred Lord

Victorian Poet Alfred Lord Tennyson (1809–92) lived at Farringford House, Freshwater, for the last forty or so years of his life. He relished its peace and solitude and thought it the perfect place to bring up his two sons. His wife Emily, on first seeing the stunning landscape, wrote, 'I must have that view.' Indeed, she did, and the family moved there in 1853.

Alfred had studied at Trinity College, Cambridge, where he met Arthur Hallam, son of historian and author Henry Hallam. Their close friendship came to an abrupt end when Arthur accompanied his father on a trip to Vienna, suffered a cerebral haemorrhage and died aged twenty-two. His death was a crushing blow for Alfred, and he grieved deeply for his lost friend, immortalised in his poem *In Memoriam A. H. H.* with the lines: 'Tis better to have loved and lost/Than never to have loved at all'.

Still mourning Arthur Hallam, Tennyson dwelt on his poem *Lazarus*, no doubt wishing that his lost friend could be likewise raised from the dead. He was mindful too of *The Raising of Lazarus* by Sebastiano del Piombo, a painting he often visited in the National Gallery and a copy of which hung over the mantlepiece at Farringford House. Alfred and Emily fondly named one of their two sons Hallam.

Tennyson visited Queen Victoria several times at Osborne House. On the death of Prince Albert in 1861, the queen wrote in her diary: 'I told him how much I admired his glorious lines to my precious Albert and how much comfort I found in his *In Memoriam*'.

Tennyson loved the bright and breezy Isle of Wight downs, remarking that 'the air is worth sixpence a pint'. He wrote *Charge of the Light Brigade* on Tennyson Down and *Crossing the Bar* on a crossing to Yarmouth from the mainland. You can see some of Tennyson's personal effects – his smoking pipes and broad-brimmed 'wideawake' hat – at Farringford Historic House and Gardens, a Grade I listed building.

Walkers can follow the scenic 14-mile Tennyson Trail, signposted from Carisbrooke and running through Brighstone Forest to Alum Bay and the Needles. The striking Tennyson Monument, a huge Celtic cross standing on the highest point of the downs, dates from 1897.

A line from Tennyson's *Ulysses* has found fame in many different locations worldwide: 'To strive, to seek, to find and not to yield.' It was quoted by Senator Ted Kennedy when he lost the 1980 Democratic Presidential nomination, and by Judi Dench as 'M' in the James Bond film *Skyfall*. The quote was also permanently inscribed on a wall of the Olympic Village for the 2012 Olympic Games in London.

Tennyson became Poet Laureate in 1850 on the death of Wordsworth, a post he held during the reign of Queen Victoria. He died Alfred Tennyson, 1st Baron Tennyson of Aldworth and Freshwater at the age of eighty-three, and was buried in Westminster Abbey. He is the most famous of the Victorian poets and the most frequently quoted after Shakespeare.

Left: Alfred Lord Tennyson. (© Julia Margaret Cameron)

Below: Tennyson Down. (© visitisleofwight.co.uk)

Thatched Church of St Agnes, Freshwater

St Agnes is the only thatched church on the Isle of Wight. Land for the church was donated by Hallam Tennyson, son of the Victorian poet Alfred Lord Tennyson, who lived nearby at Farringford House, Freshwater (see 'Tennyson, Alfred Lord', p. 77).

The church, designed by architect Isaac Jones, dates from 1908. Some of the stone used is thought to have come from an ancient and abandoned farmhouse on Hooke Hill, Freshwater, the 1635 birthplace of renowned scientist, philosopher and architect Robert Hooke, whose father was curate at All Saints', Freshwater (see 'Hooke, Robert', p. 38).

Hallam Tennyson served as governor of South Australia in 1899. His wife Audrey and their three sons accompanied him. Once in Australia, Audrey was greatly moved at the plight of expectant mothers in the outback and campaigned for better care and food for them. She obtained some funding and secured an acre of land at Rose Park, Adelaide, for a new maternity home. Local people planned to name it after her, but Audrey insisted on dedicating it to Queen Victoria. The Queen's Home, which later became the Queen Victoria Maternity Hospital, opened in 1902. Back home, and on completion of the Isle of Wight's thatched church, Audrey suggested dedicating it to St Agnes, patron saint of women and girls.

St Agnes Church is a delightful stop on the Taste Round the Island cycle route (see 'Randonnée', p. 69).

Thatched church, Freshwater. (Photo Wendy Turner)

U

UNESCO Biosphere Reserve

The Isle of Wight is England's largest island, with a milder climate than on the mainland. It's a place of outstanding natural beauty and diverse environments, from its coast and coastal paths with their chalk cliffs and beaches to its pretty villages and towns with wildflower meadows, fields, farms and rivers, surrounded by the sea. The island's woodlands are among the richest in the UK, with the coexistence of red squirrel, hazel dormouse and rare Bechstein and Barbastelle bats.

Biosphere Reserves aim to preserve and enhance the wellbeing of differing environments, to protect the countryside and waters and work towards healthier lifestyles. It focusses on sustainable relationships between people and their natural environment and ecosystems. Eco-tourism is being developed and projects undertaken towards the mitigation of climate change.

The Isle of Wight was designated a UNESCO Biosphere on 19 June 2019.

Beautiful Isle of Wight. (Photo Wendy Turner)

V

Vectis

Roman biographer Suetonius wrote of the Roman invasion of AD 43 and of Emperor Vespasian's commandeering of the Isle of Wight. He referred to the island as Vectem/Vecta from which came Vectis. The old English *Wiht* meant 'raised' and the Romans took Vectis from the Latin *veho* – 'to lift' or 'carry'. The name stuck and is used by the bus company Southern Vectis, Vectis Radio, Vectis Ventures and many other businesses on the island.

Southern Vectis bus. (Photo Ray Wilkinson)

Ventnor and Ventnor Fringe

Ventnor's gently curving shingle and sandy coast is the island's southernmost beach. It comes complete with vintage beach huts that once had wheels and were used by the Victorians as bathing machines, giving privacy to those who went down to the sea for a swim. Tiers of pretty, flowering cliffs lead to picturesque walks on the Ventnor Downs, Victorian Ventnor Park and the Botanic Garden. The Isle of Wight-shaped paddling pool, complete with road map, has been in place at the foot of the Cascade for over 100 years. Ventnor is famed for its fresh crab and lobster.

Ventnor Fringe, one of the island's largest arts and culture festivals, runs for ten days every summer. Young people living in Ventnor came up with the original idea in 2010 and it has grown year on year with hundreds of artists from around the world. The Fringe is held in various locations on the island and combines the best of what's new in the world of music, comedy and theatre. It's organised by Ventnor Exchange, a trendy venue where people meet for coffee or to sample craft beer, watch comedy and concerts and innovative theatre. Profits are reinvested to support current and new cultural development.

Cascade at Ventnor. (Photo Ray Wilkinson)

Isle of Wight pool, Ventnor. (Photo Ray Wilkinson)

The brave can take a chilly dip at the Boxing Day Swim, organised by Ventnor Carnival Association. 1,000 or so people arrive at the sea front, with around 100 taking the plunge, many in fancy dress. Funds collected support the local cancer charity.

Victoria's Island Trail

You can walk in Queen Victoria's footsteps and visit some of her favourite places on the island, following Victoria's Island Trail. The route includes her own Osborne House, plus a wide range of historic houses and castles, beautiful walks, views and sunsets that she loved and enjoyed. The walk takes in some of the island's most scenic and interesting places, with perfect stops for afternoon tea and magnificent views over the Solent.

Norris Castle on Victoria's Island Trail. (© Yale Center for British Art)

W

Walk the Wight – Mountbatten IoW

On the second Sunday in May, around 8,000 people Walk the Wight with Mountbatten, to support people facing death, dying and bereavement. The 26.5-mile route takes you around the island's beautiful countryside, woods and meadows, historic and picture-book villages, castles and celebrated houses and the famous chalk cliffs and coast with panoramic views over the sea.

The route follows an east to west direction. You can choose to walk the full 26.5 miles, the 12.5-mile first half from Bembridge to Carisbrooke, or the 14-mile second half from Carisbrooke to Alum Bay. There is also an 8-mile Flat Walk along the cycle path from Sandown to Shide, near Newport. A commemorative medal awaits at the end of the route.

Walk the Wight is a major fundraiser for Mountbatten Isle of Wight, which celebrated forty-five years of hospice care on the island in 2022, raising around £250,000 annually to support patients and their families.

Walk the Wight, Mountbatten. (© Stephanie Mackrill)

Wallis, Barnes – The Dam-Busters and the Bouncing Bomb

Sir Barnes Neville Wallis (1887–1979), legendary engineer, scientist and inventor, took an apprenticeship at Cowes shipbuilders J. S. White. He trained as a marine engineer but left at the age of twenty-six to pursue his emerging interest in aircraft. He landed a job at Vickers, where he remained for the rest of his working life.

At the start of the Second World War, Barnes Wallis studied methods of improving bomb design. Inspiration came at Chesil Beach in Dorset when he skimmed stones across the water. Inspired by the action, he saw that after enhancing it on a grand scale, bombs might 'bounce' across the surface of the water. At first his idea was met with scepticism, but Wallis perfected the technique, and it was eventually deemed likely to be outrageously successful.

The targets were three dams in the German Ruhr Valley, which, if the raid was successful, would disrupt power and water supplies, causing major damage to German industry. To be effective, after 'skipping' across the water, bombs needed to roll down the face of the dam wall and explode underwater at the base. Aircrews practiced flying their huge, specially adapted Lancaster bombers low over Derwent Dam, Derbyshire.

Lancaster Bomber *City of Lincoln*. (Photo Wendy Turner)

Derwent Dam, Derbyshire. (Photo Ray Wilkinson)

On the night of 16–17 May 1943, 133 airmen from 617 Squadron, with an average age of twenty-two, took to the skies in nineteen Lancasters in *Operation Chastise*. Bombs needed to be dropped from a height of just 18 m (60 ft) at a ground speed of 232 mph. To achieve pinpoint accuracy, a pair of lights was attached to the underside of the aircraft – the beams converged on the surface of the water at the correct height. The huge planes flew so low it was feared they might crash into the trees.

In the event, two of the dams were breached. The cost was eight bombers lost, fifty-three aircrew killed and three becoming prisoners of war, but for the Allies the raid was a huge boost to morale. 617 Squadron became a specialist precision-bombing unit.

Barnes Wallis became a Fellow of the Royal Society and was knighted in 1968. The famous 1955 film *The Dam Busters* tells the story of the Lancaster bombers' audacious raid with Sir Michael Redgrave as Barnes Wallis.

White-tailed Eagles

Six white-tailed eagles (sea eagles), Britain's largest birds of prey, were reintroduced to the Isle of Wight in August 2019. They had been persecuted throughout the Middle

White-tailed eagle. (© Ainsley Bennett)

Ages and eventually became extinct throughout the UK. The last pair on the south coast bred on Culver Cliff on the Isle of Wight in 1780.

The eagles have an 8-foot (approximately 2.5 m) wingspan. As adults, they have a distinctive white tail, a huge yellow bill and their generally brown plumage becomes paler towards the head. They have no natural predators and catch fish and waterbirds such as gulls, ducks and geese, though rabbits are on the menu where they are abundant. They will also take carrion, particularly through the sparce winter months. Waters around the Isle of Wight are rich with grey mullet, bass and black bream, which the eagles readily catch on the surface.

The project, licensed by Natural England and Scottish Natural Heritage (NatureScot), is led by the Roy Dennis Wildlife Foundation in partnership with Forestry England. The licence allows the project to release up to sixty juvenile white-tailed eagles over a five-year period, collected from wild nests in Scotland. It is hoped a breeding population of six to eight pairs might establish within 50 km of the Isle of Wight. You may be lucky enough to spot a white-tailed eagle while walking along the downs or along the coastline.

Wildheart Animal Sanctuary

The Wildheart Animal Sanctuary at Sandown lives up to its name in rescuing and nurturing big cats and other animals from poor and inhumane conditions around Europe, which includes some of the most exciting, yet threatened, animals on our planet. It builds on the work begun by the Corney family in the 1970s, when the site was known as The Isle of Wight Zoo. The sanctuary is now sheltered under the wing

Tigers at Wildheart Animal Sanctuary. (© Wildheart Animal Sanctuary)

of a charity and campaigns tirelessly on the island, and further afield, helping to ensure the protection of every animal.

If you enjoy engaging with tigers, lions, lynx, lemurs and a host of other appealing wildlife, then you can visit the sanctuary all year round, adopt an animal or book an animal experience at the sanctuary or online.

Wroxall: The Sunshine Loop

The village is so named for the longest hours of sunshine in the country, averaging thirty-seven hours of sun per week. The area is incorporated into the Red Squirrel Trail.

X

Xylophone Fence

The xylophone musical fence installed along the seafront at Small Hope Beach, Shanklin, was created in 2006 as a fun and artistic installation, part of the Island 2000 Trust (now Natural Enterprise). It was made from pine and cut into various lengths by its creator Daniel Roberts, to produce the notes needed to play *Oh I do like to be beside the Seaside* when played like a regular xylophone.

It took weeks of painstaking hollowing-out the back of each piece with a sander to produce the final tuning. Sadly, a cliff fall ended the days of the xylophone fence on the seafront, but during its lifetime it brought happiness and entertainment to hundreds of people enjoying a day out. It also supported Gift to Nature, a wildlife and conservation charity, via a donation box on the seafront.

Fun xylophone fences were also installed in nurseries at Sandown and on the mainland. The Sandown nursery's xylophone fence had a close shave on delivery when Daniel fitted it with wheels and towed it behind his bicycle along the Cowes to Sandown cycle path. After becoming wedged in a set of gates, a friend with a large van came to the rescue in the early hours. Daniel is also the founder of the island's National Poo Museum (see 'National Poo Museum', p. 54).

Daniel's famous xylophone fence has appeared on TV's *You've Been Framed*.

Daniel Roberts constructing the xylophone fence. (© Daniel Roberts and Ian Boyd)

Y

Yarmouth Harbour

Yarmouth Harbour is one of the island's main attractions, welcoming thousands of visitors each year.

Boats entering the harbour pass over two of the Solent's seagrass meadows. Seagrasses live and flower underwater, frequently growing in groups resembling underwater meadows. They offer habitats and shelter for a multitude of wildlife, including crabs and both species of seahorse native to UK waters.

Saltmarshes around the Western Yar estuary are revealed in all their multicoloured glory as the tide turns. The little streams and pools are a haven for a variety of fish and invertebrates and attract a host of resident and migratory birds. Among the most spectacular is the sandwich tern, which dives into the water for sand eels and sprats. It is named after Sandwich Bay, Kent, one of three British birds named after the county of Kent.

Grade II listed Yarmouth Pier is the last wooden pier of its type in the UK. It opened in 1876 to accommodate ferries and steamers. A Pier Appeal Fund headed by its patron, television's Alan Titchmarsh, and a Heritage Lottery Fund grant, ensured its restoration. Its upkeep is ongoing due to wood-boring creatures such as the gribble (*Limnoria lignorum*). The pesky creature is humorously portrayed in the form of an

Yarmouth Harbour.
(Photo Ray Wilkinson)

Y

Above: Crabbing, Yarmouth Harbour. (Photo Wendy Turner)

Right: Gribble seat at Yarmouth Harbour (Eccleston George). (Photo Ray Wilkinson)

eye-catching gribble seat on the quay, complete with its startling blue eyes and fearsome teeth. It was created by local artists Eccleston George using reclaimed materials.

Yarmouth Castle was built next to the quay, giving it control of the river's landing point. A state-of-the-art castle during the reign of Henry VIII, it was completed in 1547 to protect the western Solent and prevent the enemy using the Isle of Wight to attack the mainland. Inside the castle, you can relive sixteenth-century life and take in tales of countless ships lost in its dangerous waters.

The harbour teems with wildlife, and children and adults alike can try their hand at crabbing from the designated crabbing area.

Yaverland

Yaverland is the perfect spot for sea, sand and swimming, with a wide range of water sports. It has both orange sandstone and white chalk cliffs and is a focus for fossil and dinosaur hunting. Guided fossil walks can be booked at Dinosaur Isle.

Z

Zig Zag Road, Ventnor

The name appropriately reflects the hairpin bends that wend their way down to the sea. Some Grade II listed properties can also be found in Zig Zag Road.

Left: Zig Zag Road, Ventnor. (Photo Ray Wilkinson)

Below: Zig zags at Zig Zag Road, Ventnor. (Photo Ray Wilkinson)

Zion Chapel, Ryde

The chapel was founded by William Shakleton the Elder in 1853 as a free Wesleyan preaching house. Together with his son, also William, and grandson Ernest, a board of trustees was established to run the chapel, which still holds good today. So successful was the chapel that at one point over eighty children attended its Sunday school.

Beryl Shakleton, wife of Ernest, established Bright Hour, a regular meeting of ladies who brought comfort and practical help to the local community during the years of austerity and rebuilding following the Second World War. The group made blankets for needy local families and put together shoeboxes with Christmas gifts for needy families in Romania. Zion Chapel Evangelical Church continues to contribute funds for local charities and for the sick in India. 'God' was once fondly described by a young child as 'that friend of Mrs Shakleton's'!

The chapel is an active member of the Evangelical Association, and Christian worship remains at its core. Brian Sexton is the current chair and leader.

Zion Chapel, Ryde.
(© Zion Chapel Ryde)

Acknowledgements

The author and publisher would like to thank the following people/organisations for permission to use copyright material in this book: Ainsley Bennett, Susan Bixley, Blackgang Chine, Brading Roman Villa, Brading Town Trust, Elizabeth Manning, Ruth Waller, Helen Butler MBE, Carisbrooke Castle Museum Trust, Chillerton and Gatcombe Community Association, Richard Crossley, Dimbola Museum and Galleries (Julia Margaret Cameron), IoW Donkey Sanctuary, English Heritage/Historic England, Ever Sculpture Garden and Cottage, The Garlic Farm, IoW Ghost Experience, Rita Greer (artist), Godshill Church, Jeremy Irons, St James' Church East Cowes, Cllr M. Lilley, Stephanie Mackrill, Medway Queen (medwayqueen.co.uk), Ian Mitchell, The Museum of Ryde, Donald McGill Postcard Museum (Greaves & Thomas), National Trust, Chris Offer, Old Thatch Teashop, Shanklin, Osborne House, Quarr Abbey, IoW Ramblers, Daniel Roberts and Ian Boyd, Sandown Airport, Southern Vectis, Bob and Chris Tebbutt, Christine Tout, Peter Trimming, Mr P. Tumber, visitisleofwight.co.uk, Wellcome Collection, West Wight Alpacas and Llamas, Wight Aviation Museum, Wildheart Animal Sanctuary, Mr Ray Wilkinson, Yale Center for British Art, and Zion Chapel, Ryde.

With special thanks to Ray Wilkinson; Mrs Mary Pointer; Dinosaur Isle; Forestry England; RNLI; The Robert Hooke Society; Shanklin Chine; IoW Steam Railway; St Mary the Virgin Church, Brading; St Mildred's Church, Whippingham; Thatched Church, Freshwater; Ventnor Botanic Garden; and Walk the Wight Mountbatten.

Every attempt has been made to seek permissions for copyright material used in this book. However, if we have inadvertently used copyright material without permission/acknowledgement, we apologise and we will make the necessary correction at the first opportunity.

Bibliography

Boynton, L. O. J., *Appuldurcombe House* (English Heritage: London, 1967 and 1986; previously published by HMSO, 1967)
Carey, Paul, *Sandown Aviation Shed: Black Arrow* (Wight Aviation Museum, 2019)
Gazzard, Jacqueline, *Brading Roman Villa Guidebook* (Oglander Roman Trust, 2012)
Graves, Robert, *Goodbye to All That* (Jonathan Cape, 1929 and 1958)
Hewitt, Peter, *A Guide to Godshill Church (Illustrated)*
Isle of Wight Guide (Red Funnel, 2021–22)
Orwell, George, *The Art of Donald McGill: An Essay by George Orwell* (Greaves & Thomas, England 2009) – originally written for and published by *Horizon*, 'A Review of Literature and Art' (September 1941)
Quarr Abbey: A Guide and History (Hudson's Heritage Group and Quarr Abbey, 2012)
Shanklin Chine Isle of Wight: Past and Present (shanklinchine.co.uk)
The Yarmouth Harbour Visitors' Guide (Horizon Publishing, 2021 and 2022)
Young, Christopher, *Carisbrooke Castle* (English Heritage Guidebooks)

Websites

Cowes Hammerhead Crane Trust (coweshammerheadcrane.org.uk)
Cowes Week (cowesweek.co.uk)
Cycle Island (cycleisland.co.uk)
HMP IoW (http://www.gov.uk)
Hovercraft Museum (hovercraft-museum.org)
Isle of Wight Council (iow.gov.uk)
The Needles (theneedles.co.uk)

About the Author

Wendy Turner lives in Hertfordshire and has been writing articles for many years for a variety of magazines, including *This England, Evergreen, People's Friend, The Countryman and Veracity*, the online magazine of Verulam Writers, St Albans, Herts. The *A–Z of the Isle of Wight* is her third in the series, after the A–Zs of St Albans and Lincoln. She is a keen photographer (point and shoot!) and is delighted to have discovered the wonderful treasures of the Places, People and History of the Isle of Wight.